ROSS-ON-WYE
THROUGH TIME
Emma Cheshire-Jones

AMBERLEY PUBLISHING

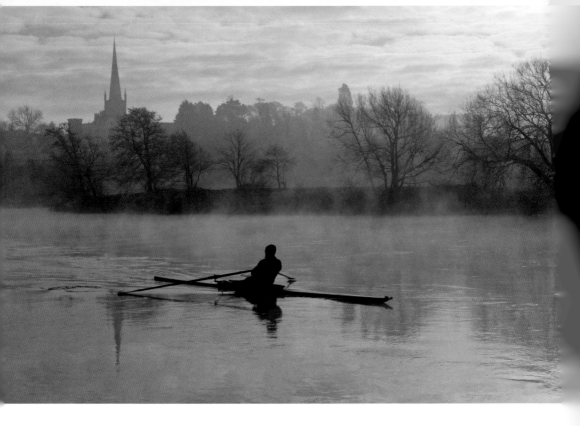

Dedicated to the memory of Gordon and Margaret Lucas, true Rossians, whose devotion and commitment to the town and its people was selfless. Also a huge personal thank you to everyone I have met and known in the town. Ross will always be a special place to me.

First published 2013

Amberley Publishing
The Hill, Stroud
Gloucestershire, GL5 4EP

www.amberley-books.com

Copyright © Emma Cheshire-Jones, 2013

The right of Emma Cheshire-Jones to be identified
as the Author of this work has been asserted in
accordance with the Copyrights, Designs and
Patents Act 1988.

ISBN 978 1 4456 1643 8 (PRINT)
ISBN 978 1 4456 1662 9 (EBOOK)

British Library Cataloguing in Publication Data.
A catalogue record for this book is available from
the British Library.

Typeset in 9.5pt on 12pt Celeste.
Typesetting by Amberley Publishing.
Printed in the UK.

Introduction

Ross-on-Wye sits high on a sandstone cliff overlooking a horseshoe bend in the beautiful River Wye. The first reference to the town was in 1016 in a document presented to the Bishop of Hereford. It is also referred to in the Domesday Book of 1086 as a village and manor of the Bishop of Hereford with a priest and a mill, thus indicating Ross had emerged as a settlement with a church and corn mill.

It is the birthplace of the British tourism industry thanks to Ross Rector Dr John Egerton. In 1745 he started taking friends staying in his rectory on boat trips down the River Wye. Its attraction was undoubtedly the scenery, abundant wildlife, picturesque farmland, castles and abbeys – notably Tintern. In 1782, William Gilpin published *Observations on the River Wye*. It was the very first tour guide to be published in Britain and, as demand grew, by 1808 there were several boat trips making excursions down the Wye, most hired from inns in Ross and Monmouth. Now an Area of Outstanding Natural Beauty, the Wye Valley offers locals and visitors a rich tapestry of heritage and a unique landscape.

The parish church of St Mary's is the town's most prominent landmark, and with its tall, pointed spire it is visible on all approaches into the town. It also holds several notable tombs. William Rudhall's (*d.* 1530) is one of the last great alabaster tombs made by the sculptors in the specialist masons in Nottingham, their work being prized throughout medieval Europe. Rudhall was responsible for the repair of the Church Street almshouses in 1575, situated in full view of the church. Another tomb is that of John Kyrle. A prominent figure in Ross in the eighteenth century, his name was given to the local high school and one of the town's notable inns, the Man of Ross. He was immortalised by the poet Alexander Pope for his good deeds for the sick and needy of the town. The entire population of Ross attended his funeral, to show their gratitude towards him. He is sometimes remembered on John Kyrle Day when bread hedgehogs, the symbol of Ross, are given out to the children of the town. There are at least fourteen examples of this symbol in the church, nine of which are on the shield in the Markye Chapel. This association goes back some 1,500 years to when the Celts invaded and called the area '*Ergyng*', which meant 'Land of the Hedgehog'. This was changed in Saxon times to Arkenfeld and later again to Archenfield.

Ross grew up on the banks of the River Wye on the low ground near Wilton Castle. If it wasn't for the fact that it flooded, Wilton could well

have become a larger settlement that Ross itself. Instead, people opted for the safety of higher ground.

At one time the town could boast that one in three buildings was an ale house and one in five a butchers. Every three butchers had an abattoir, so different from today.

Royalty has played a large part in Ross history; it owes its modern road system to King George IV, who had to travel through the town on his way from South Wales to London in the early nineteenth century.

He became very angry with the local townspeople when his carriage became stuck as he was trying to negotiate the narrow streets around the Market House area. A large cart had shed a wheel and blocked the entrance to Arthur's Lane. The King had to spend the night in Ross and when he returned to London the next day he decreed that if Ross didn't change its road system they would be taken off the lucrative mailing routes. This was done in due course and a wider Gloucester Road was built, with Arthur's Lane becoming Old Gloucester Road.

More recent famous names include the dramatist Dennis Potter – most famous for *The Singing Detective* – who lived in Ross for most of his life. He died in 1994 at the age of fifty-nine. Richard Hammond, of BBC's *Top Gear* fame, lives near Ross-on-Wye. During the 1960s and early 1970s, Noele Gordon, actress in the *Crossroads* television soap opera, lived at the large whitewashed country house called Weir End, near Ross, beside the A40 road to Monmouth. She is buried in St Mary's churchyard in the town.

Today Ross is known for its independent shops, picturesque streets and Market Square with ancient Market Hall. Regular Thursday and Saturday markets are still held adjacent to the red sandstone Market House building, which houses a visitor centre upstairs.

This fascinating collection of old and new images shows how much and, in some cases, how little this historic market town has changed.

Acknowledgements

Mary Sinclair Powell, History with a Twist; Tim Ward; Dennis Morgan; Richard Mayo, Truffles Delicatessen; Rob Sedman, Lily-Elsie.com; the *Ross Gazette*; Cancer Research UK; Nick Dale; John and Betty Gartside; the Lucas Family; Ross in Bloom; Ross Branch, Royal British Legion; Ross Garden Store; Ross-on-Wye Town Council; Wyenot.com; ecjphotography.com; Ross-on-Wye Photographic Society; and all those individuals who have encouraged me with this very enjoyable project.

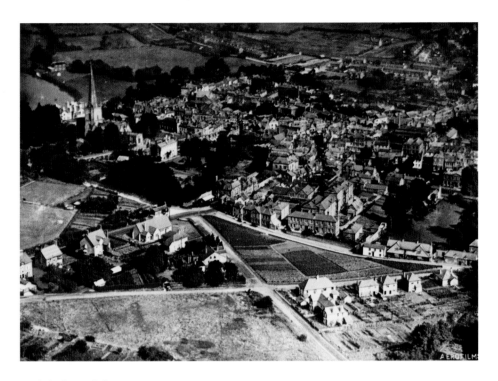

Aerial View of the Town

This bird's-eye view of the town, taken in 1932, clearly shows the triangular piece of land in the middle that was the garden for the workhouse. Founded in 1836, it gave overnight accommodation in return for work. Men had to break five hundredweight of road stone, with fourteen days in prison for failure, an option some tramps took during the winter. It was demolished in 1995, the area in Alton Street becoming the Community Hospital and a doctor's surgery.

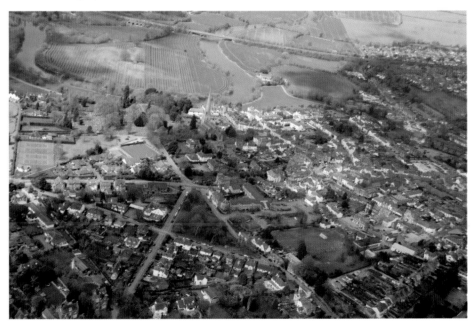

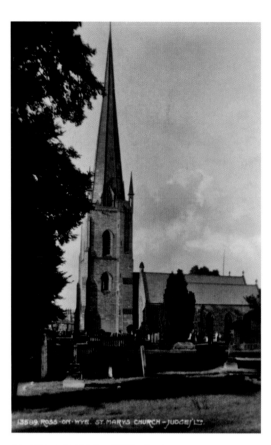

St Mary's Church

Ross's most prominent landmark, with its tall, pointed spire, is visible on all approaches into the town. Originally founded by Robert de Betun, Bishop of Hereford in the thirteenth century, it was dedicated in 1316, but there is evidence to suggest Saxon and Norman churches were situated here before the current one was built. The spire towers 205 feet into the air and dates from the fourteenth century.

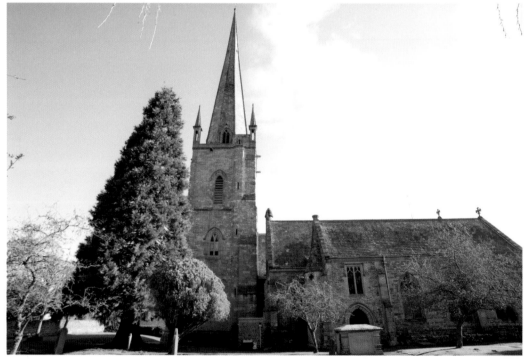

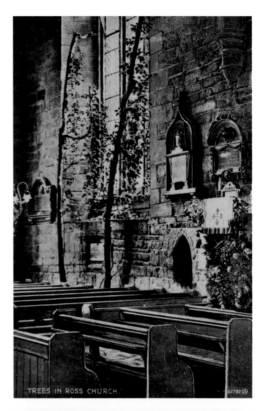

TREES IN ROSS CHURCH

Trees in St Mary's Church

Elms were planted in the churchyard, and suckers came through the walls into the church. The parent trees were cut down during the church restoration of 1878, and more elms were planted to the south of the church in 1899. The trees inside the church died, but their remains stood there until around 1953, when, riddled with woodworm, they were destroyed. Today vines are growing inside up the iron stands.

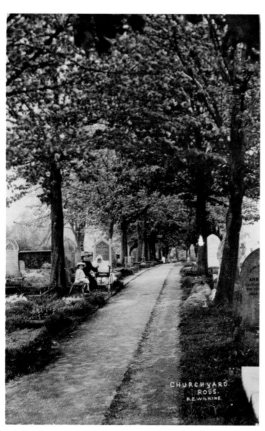

St Mary's Churchyard
A different pace of life some 100 years ago left time to enjoy the sun after a quiet stroll with the children. You can still enjoy reflective moments here today, taking care where you sit, as some of the ancient trees have become one with the bench.

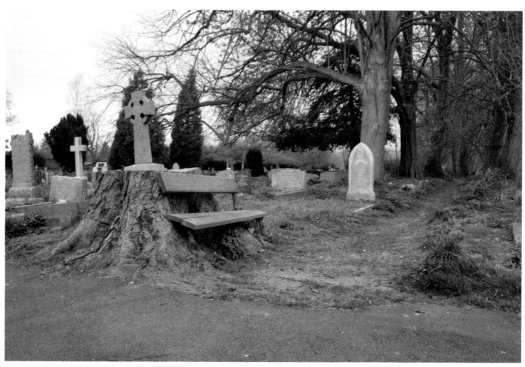

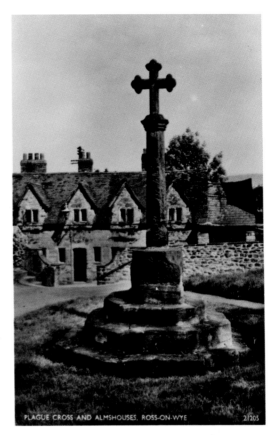

PLAGUE CROSS AND ALMSHOUSES, ROSS-ON-WYE 2/205

The Plague Cross

Originally the Preacher's Cross, it was restored in the churchyard of St Mary's as a memorial to the 315 people who died from plague in the town in 1637. They were buried at night in a pit nearby without coffins. By 1869 it had fallen into disrepair and the top of the cross was missing. It was restored again to its former state.

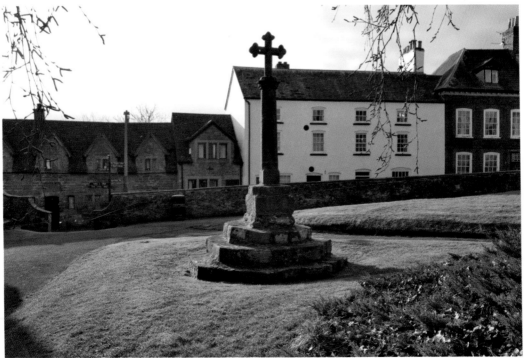

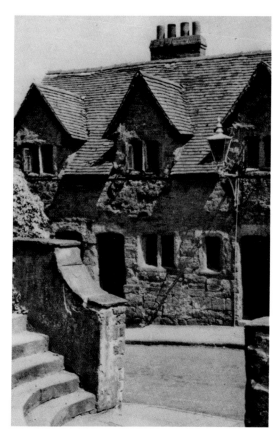

Rudhall's Almshouses, Church Street
Founded in the fourteenth century, the almshouses were occupied by five poor men or women who were each given an annual allowance of 30s. As with all almshouses they alleviated the suffering of the poor, and the elderly of the shame of entering the workhouse to end their days. Although altered in 1960 as accommodation for three older people, externally they have stayed the same.

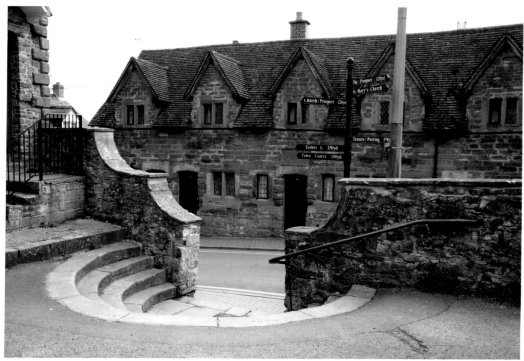

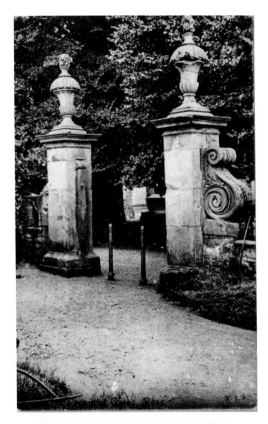

The Prospect Gardens Gateway
The gateway seen above is the original built
by John Kyrle as the entrance way into
the Prospect Gardens. The gates fell into
disrepair and new ones were commissioned
by public subscription in 2000 to celebrate
the new millennium. Over the years many
thousands have passed through on their
perambulations since the eighteenth century
to marvel at the superb views of the river
and beyond.

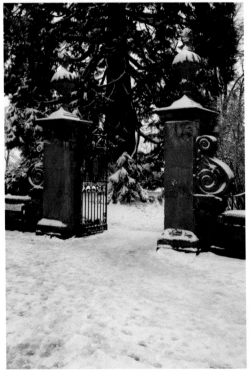

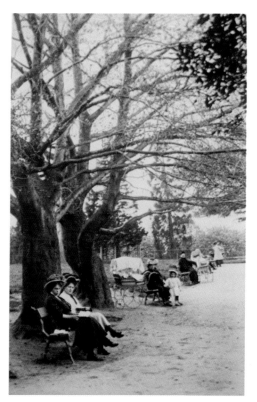

The Prospect Gardens
Around 1910 these elegant ladies were enjoying the views over to the Black Mountains in the afternoon sun. Situated next to St Mary's church, the area was rented by John Kyrle from the Marquis of Bath in 1696 and turned into a garden and walking area. Thomas Blake later purchased it and the freehold was given to the townspeople. It now contains a number of trees dedicated to local people.

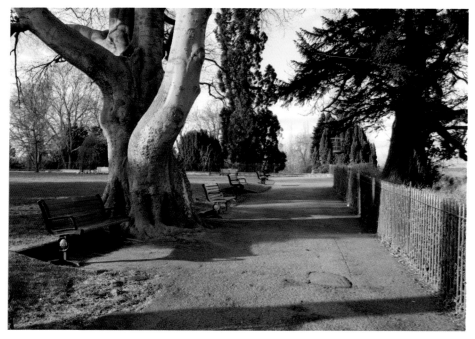

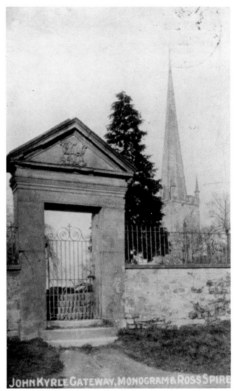

John Kyrle's Gateway
This Grade II listed gateway between the south side of the Prospect and the churchyard was built as the finishing touch to the gardens by John Kyrle in 1700. Comparing the 1904 postcard with the modern view, you can see it has changed very little, and is as popular today as a part of the riverside walk as it was then.

JOHN KYRLE GATEWAY, MONOGRAM & ROSS SPIRE

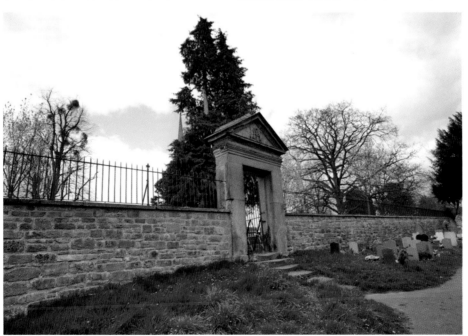

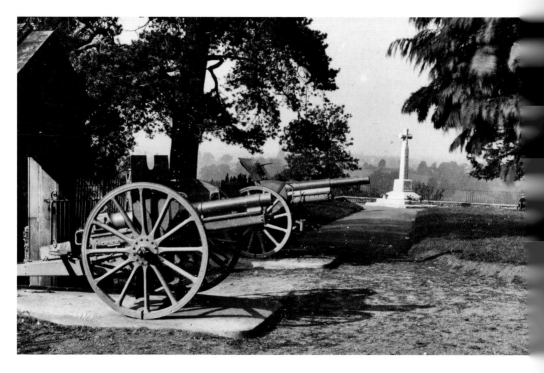

War Memorial

Flanking John Kyrle's Gate you see two First World War field guns. They were placed here to 'guard' the new war memorial. This was moved when the retaining walls were repaired a few years ago, and it now occupies a more appropriate position for Acts of Remembrance.

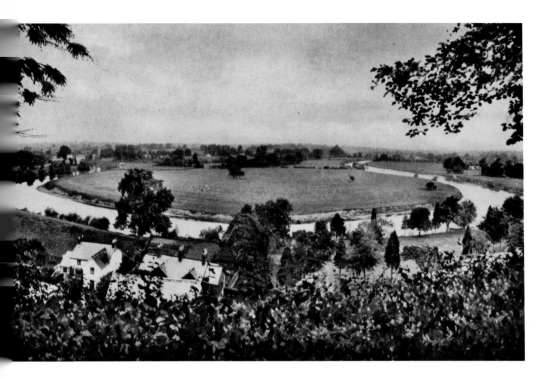

Horseshoe Bend, River Wye

This spectacular view from the Prospect overlooks the River Wye with the Black Mountains in the distance. It is easy to see why the gardens were created for the townspeople to enjoy. It is still a stunning view, with the Wye snaking its way round some 100 feet below.

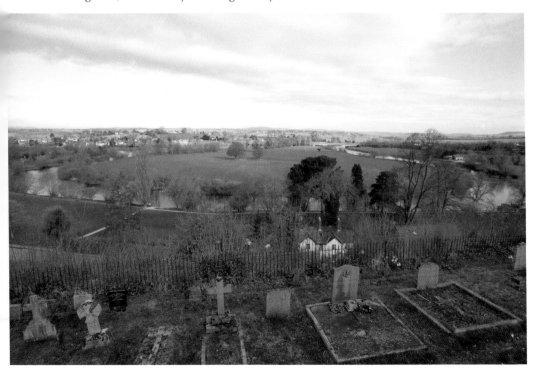

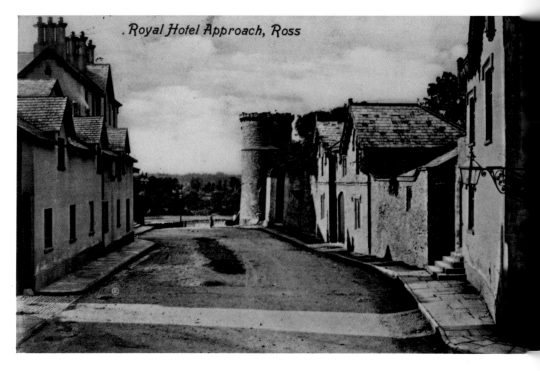

Palace Pound

The Gazebo Tower is part of the mock Gothic walls, erected when the new road was put through in 1833. This new road from Wilton took traffic away from the riverside, which flooded regularly. The tower was built as a viewing point and is one of the finest examples of a folly in Herefordshire. Now in private ownership, it is used as a holiday home but is occasionally open to the public. Little has changed in the 100 years between these photographs.

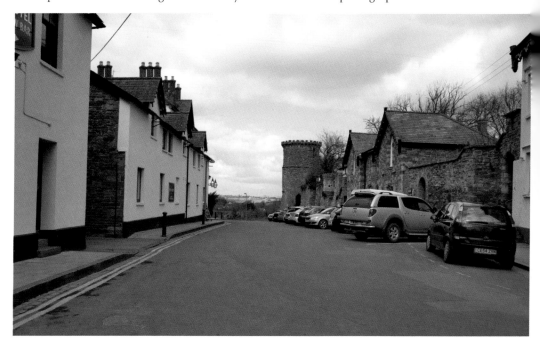

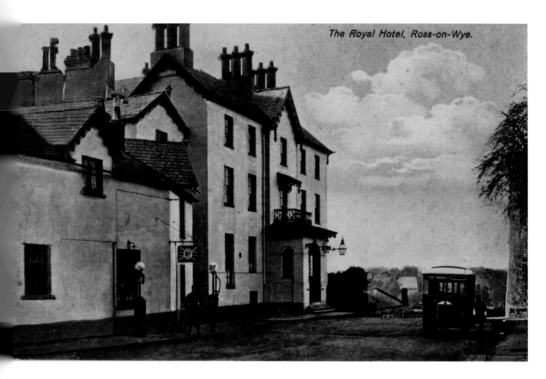

The Royal Hotel, Ross-on-Wye.

The Royal Hotel

Dominating the skyline since it was opened in 1837, this Georgian Grade II listed country hotel was a favourite of Charles Dickens (1812–70). He loved Ross and had a room almost permanently booked here (there is a bronze plaque inside the front door recording the loyalty of the author of *Bleak House*). Dickens' business manager, George Dolby, lived on the outskirts of the town.

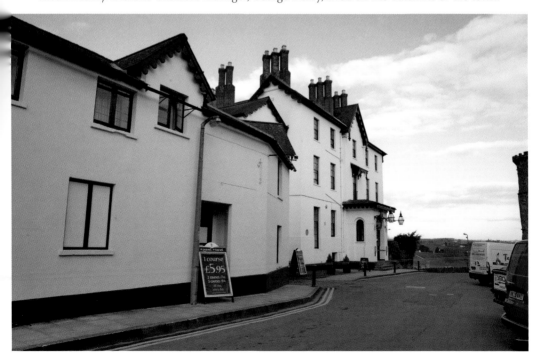

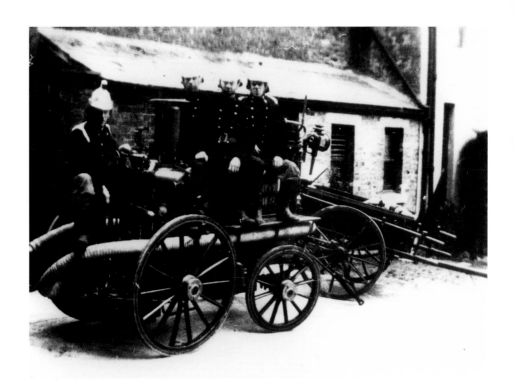

Phoenix Theatre

The original site of the local Victorian fire station, the Phoenix was ideally situated next door to the Royal Hotel, where the horses could be stabled. Previously they were kept on the riverside and quite often in the time it took to catch them, the fire would either be too out of control or completely out anyway. The local theatre company moved here in the late 1970s.

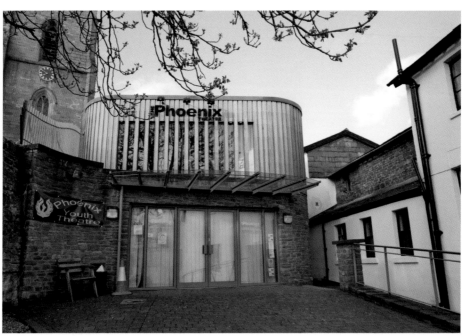

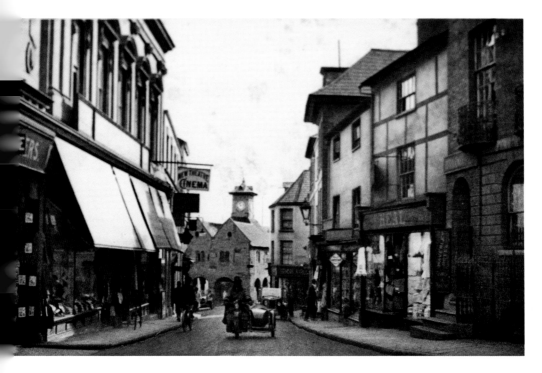

High Street

This general view from the 1920s shows how little has changed in the last ninety or so years. The sign for the King's Head Hotel is still there and, apart from changes to the names on the shopfronts, it can still boast a great many independent shops selling a variety of goods.

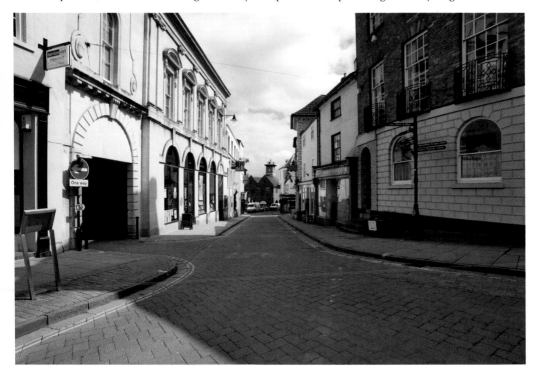

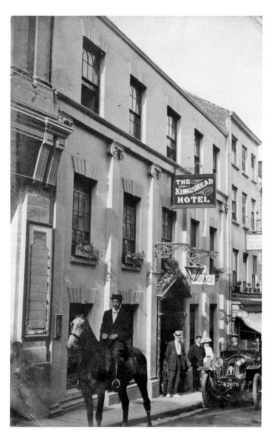

The King's Head Hotel

Taken in around 1910 when cars were making their first appearances on the streets of Ross, this popular coaching inn has been in continuous use since the seventeenth century. It has a wealth of history, with a beamed and paneled interior. In recent years the stables where coaching horses were changed have been integrated into the restaurant, and visitors can marvel at the depth of the original well, which is still very much in evidence.

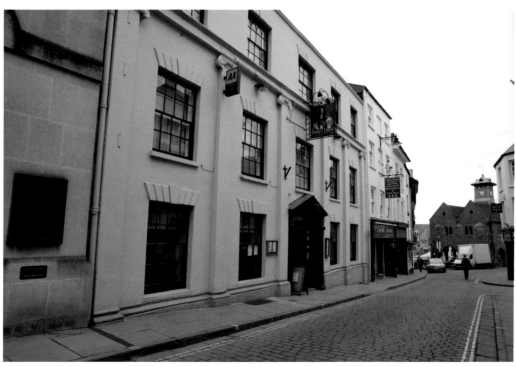

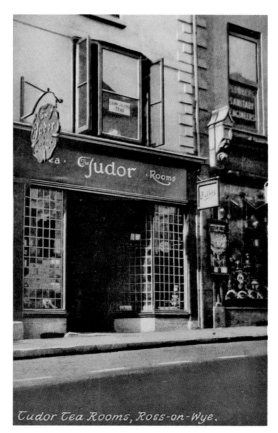

No. 38 High Street, Tudor Tea Rooms
This was a well-known café in the town
from 1933 to 1949. Times may have
changed with the onset of the 1960s coffee
bars and modern-day bistros, but these
quaint independent places are becoming
more popular once again. No. 38 is now
a gentlemen's hairdresser but you can
still find traditional tea and coffee shops
within a few yards.

Tudor Tea Rooms, Ross-on-Wye.

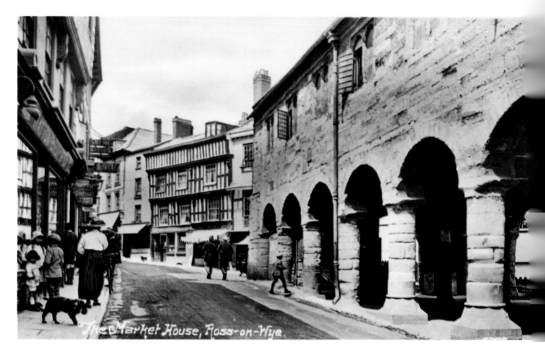

The Market House, Ross-on-Wye.

Saracens Head

Recorded as being an inn as early as the seventeenth century, it is one of the most photographed buildings in the town after the Market House. The timber-framed building in the centre of this picture has rich carvings on the beams beneath the eaves, which were revealed in the 1890s after being hidden for many years under layers of plaster. Recently restored, it is one of the few remaining half-timbered buildings in the town.

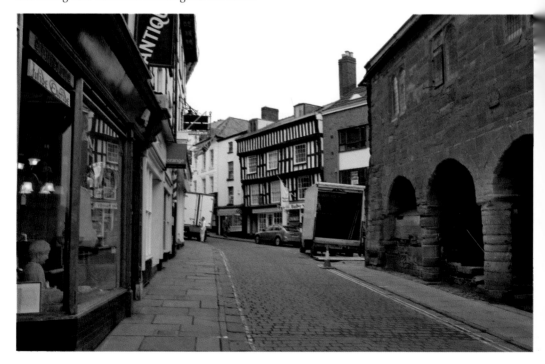

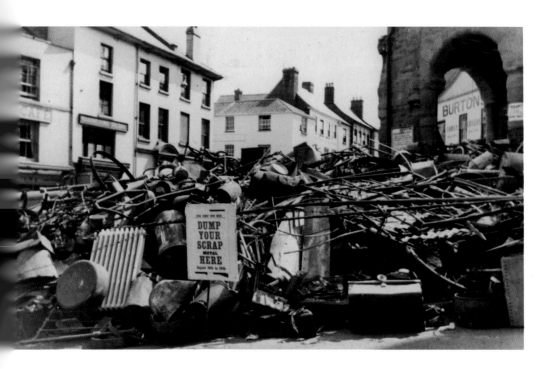

Market Day

This is the focal point in the centre of town, and the most photographed view. Ross was granted a charter in the twelfth century by King Stephen to hold a Thursday market. Photographed around 1943, the scene above shows the campaign during the Second World War to gather scrap metal to be turned into vital machinery and weapons. Thursday and Saturday markets are still held here today.

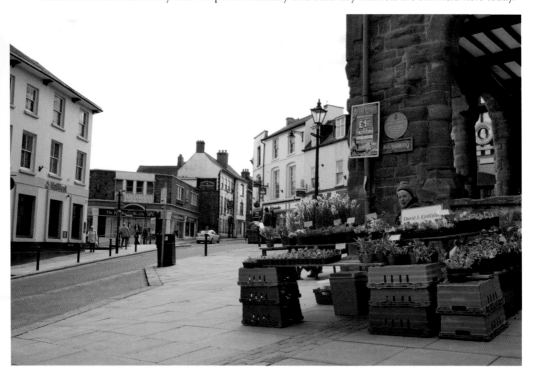

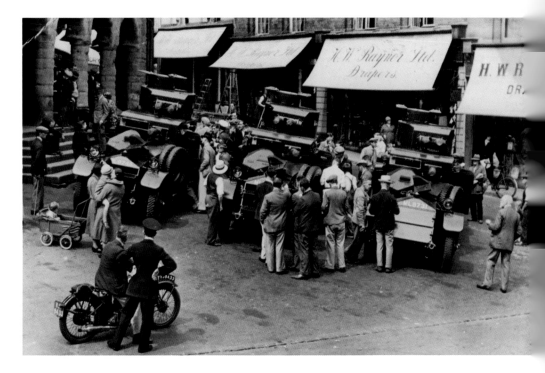

Market Square

In the early 1930s a contingent of the Royal Gloucester Hussars lined up their Rolls-Royce armored cars outside the Market House for a recruitment drive. Today the square is still the hub of the town, with the area being used as a setting for major events including the annual May Fair and Pancake Day races.

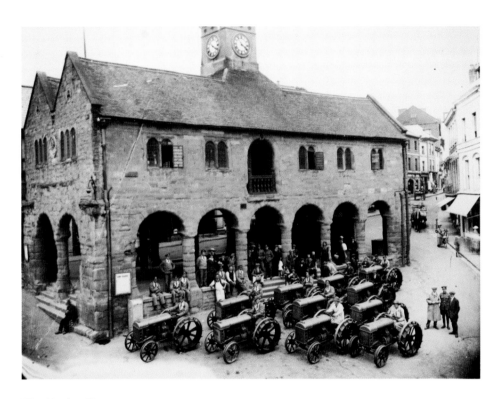

The Market House

Built to replace the old Booth Hall around 1650–54, it was constructed from local red sandstone and Forest of Dean oak. It was once used as the town hall and magistrates' court but now houses a visitor centre upstairs. Photographed at the end of 1917, these Fordson tractors were imported from the USA by Passey & Hall, the local dealership. The tractors cost £220 and it was an £70 for the plough. They were to be used by the Women's Land Army and wounded soldiers, but arrived too late for the harvest and were used for contract ploughing by the Army.

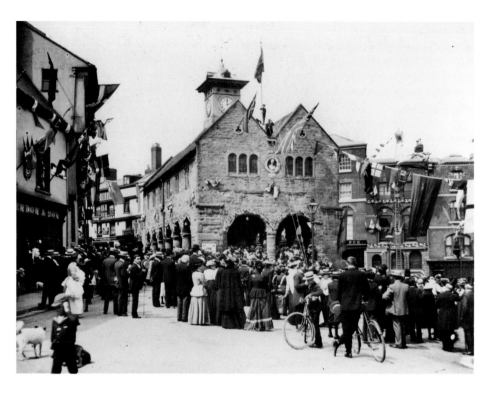

The Market House, East Side

The roundel on the building is a bust of Charles II. The original was commissioned by local people in the 1700s, and the one you see today is a 1955 replacement. There is also a logogram set into the building by John Kyrle – a loyal Royalist – because he could not see the bust from his house. The letters 'F' and 'C' are interlinked with a heart and mean 'Faithful to Charles in Heart'.

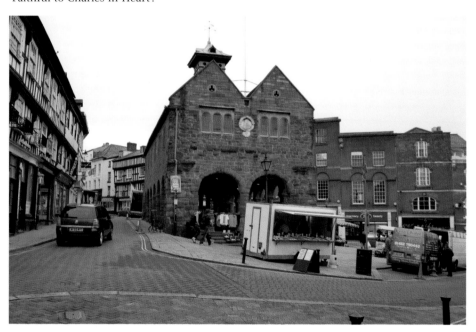

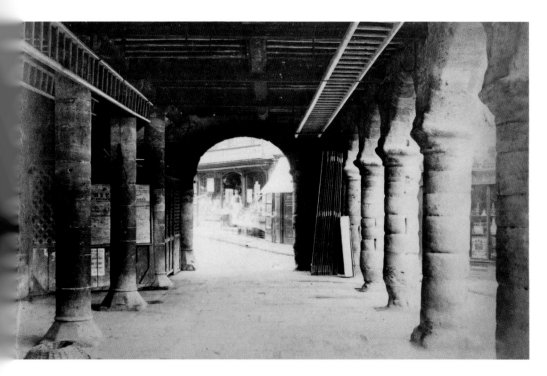

Market House Arches

Until the turn of the twentieth century the fire brigade and ladders were kept in the Market House, where the fire bell was situated. The first person to ring the bell got 1s, but anyone who did it when there was no fire was fined 5s. The hole for the bell rope can still be seen under the archways in the picture above. Market stalls were also stored here for anyone wishing to use them.

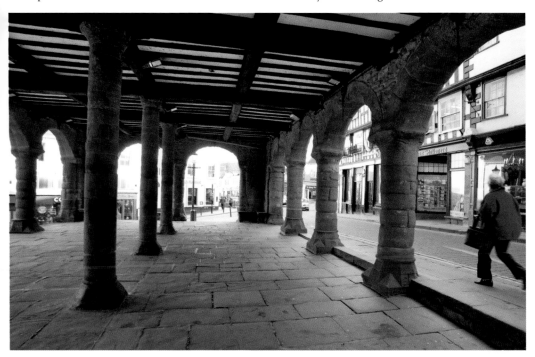

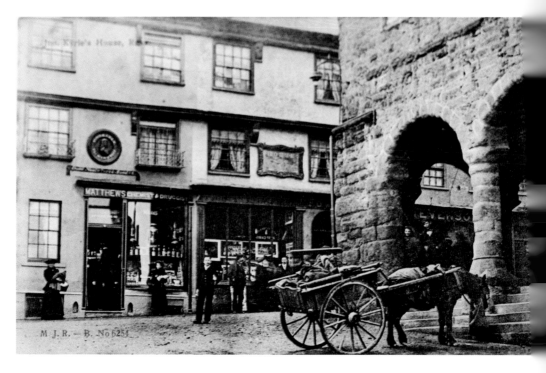

No. 34 High Street, Man of Ross House

The Man of Ross, John Kyrle (1637–1724), was a major benefactor of the town, giving generously to the needy, infirm and those who sought his advice. The rare 1905 picture above shows none of the timber work you see today. It was plastered over by the Victorians who thought it old fashioned. When Kyrle died it became an inn, the King's Arms, which closed in 1805. It was then separated into a chemist and a printing works and was the offices of the *Ross Gazette* for many years.

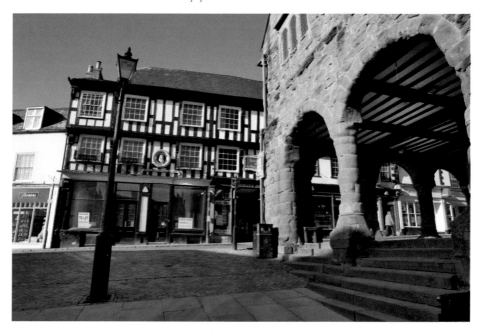

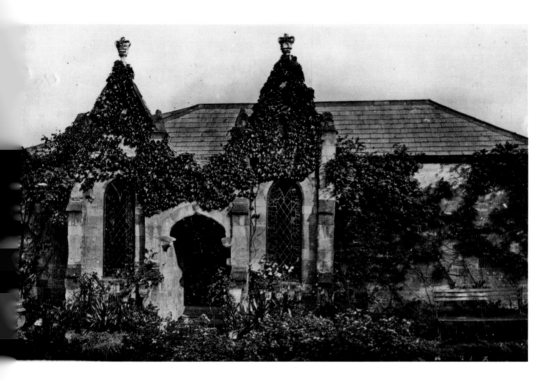

John Kyrle's Summer House

Situated behind the Man of Ross House, it was commissioned around 1700 as a gentleman's retreat. It became a folly with the knot garden added in 1820 by the owner, Mr Cary-Cocks. It has several interesting features, including a swan mosaic made out of teeth reputed to have been taken from the horses that fell in the Civil War battle for Wilton Bridge. A sight on the tourist trail and worthy of a postcard in 1918, it is now a private residence with the stunning gardens fully restored.

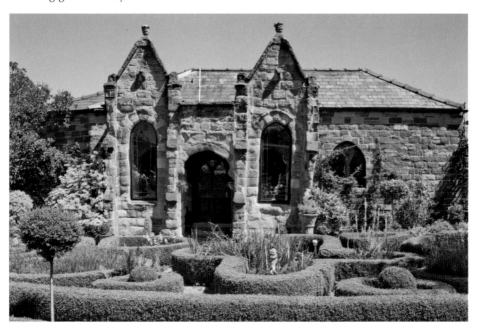

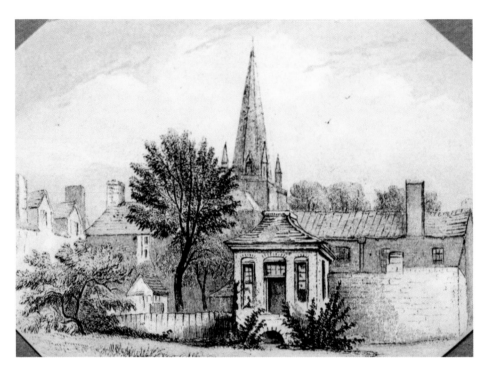

John Kyrle's Original Summer House

This engraving is believed to date the original Summer House to pre-1700s. Much smaller than the later building it was more of a store and shelter for use with the adjacent bowling green. Now in disrepair, there are moves afoot to look into restoring this important piece of history in the town.

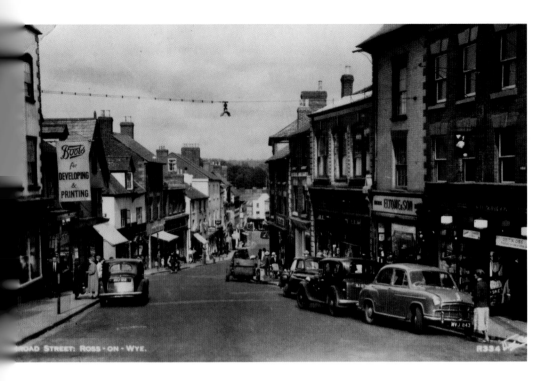

Broad Street, General View

As you can see, very little has changed in this street since the above photograph was taken in the 1950s. Boots has moved further up the hill and Eltomes' is still a gentlemen's outfitters. Traffic was still going both ways in the street until 1997.

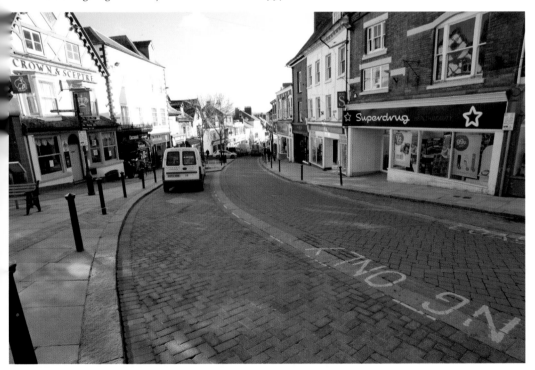

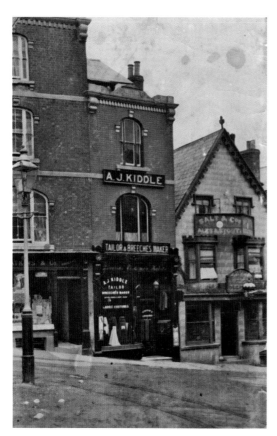

No. 6 Market Place, Crown and Sceptre
Seen here on the right-hand side, this inn dates back to the seventeenth century and still keeps its original name and the architectural features of the period. It was owned by Alton Court Brewery along with several other pubs and inns in the town until around 1928 when the brewery closed. To the left is No.7, A. J. Kiddle, general outfitter's, now the Nationwide building society.

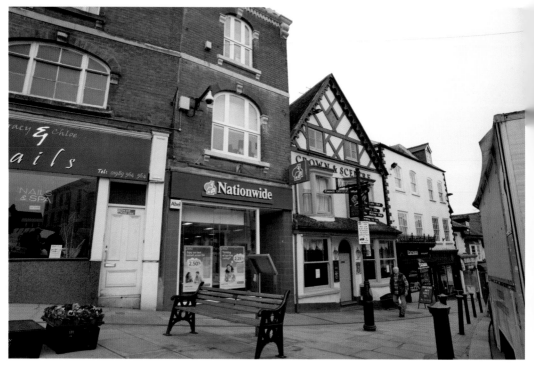

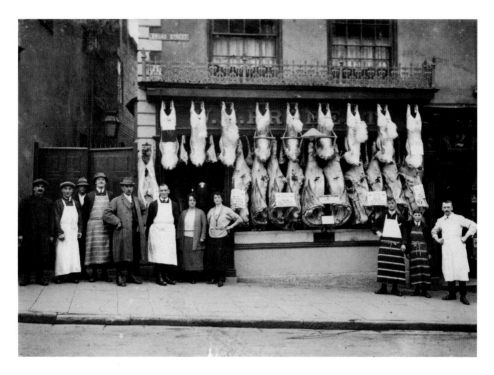

No. 1 Broad Street, Parsons Bakery

A hundred years ago there were no issues with where the meat came from. The Probert Brothers had two shops in town and their meat was from animals reared at Alton Court Farm by William Probert himself. This 1910 scene shows their abundance of Christmas fare. Unfortunately, butchers can no longer hang their meat outside the shop, but this does not detract from the quality found at local independent butchers today.

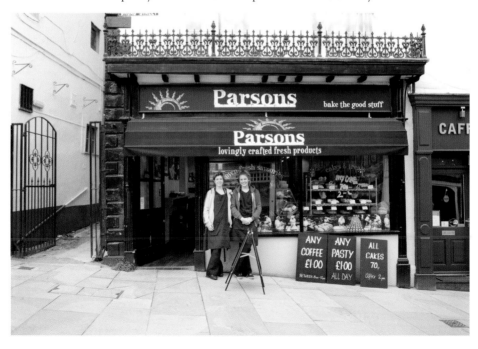

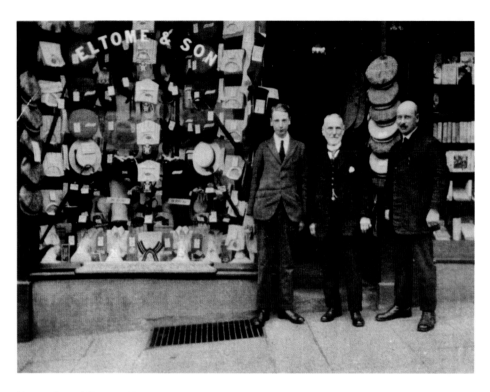

No. 55 Broad Street, Mervyn James

In 1928 George Eltome was the proprietor of this family business; he had been an apprentice in Cheltenham before coming to Ross. The business went on to span the three generations seen here. Despite a change of ownership in 1963 it has continued as a traditional gentlemen's outfitters for over 100 years.

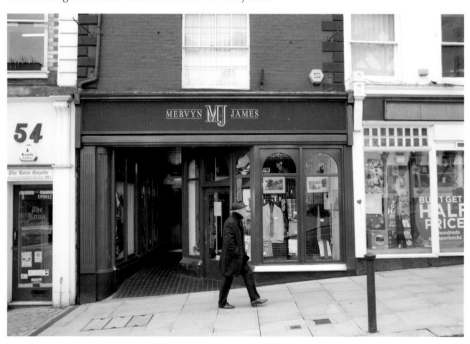

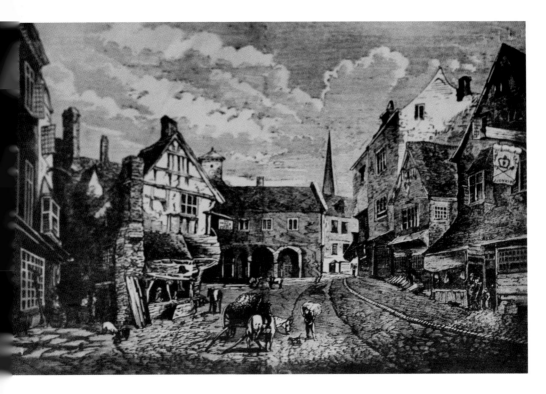

Underhill

This was a row of shops and houses at the top of Broad Street. The original Booth Hall was attached to them. Described by the inhabitants as 'Under Hell', one can imagine how awful it was to live and work in this rat- and flea-infested tenement. The building was demolished in the early 1800s.

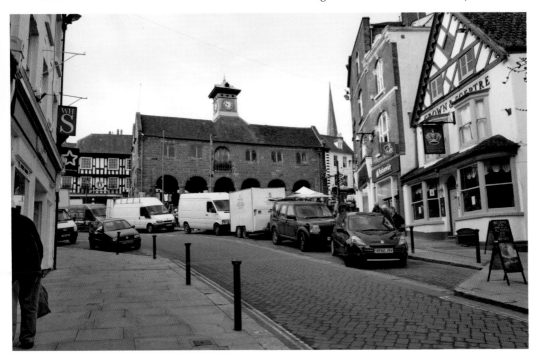

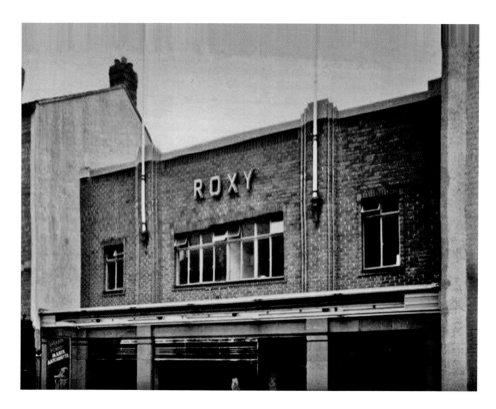

The Roxy Cinema

When opened in 1939, the cinema's Art Deco interior made it a popular venue for entertainment and dining. It boasted 'only first-class films' and 'first-class cuisine'. It continued as a cinema until around 1982 when it was demolished and converted into The Maltings shopping area.

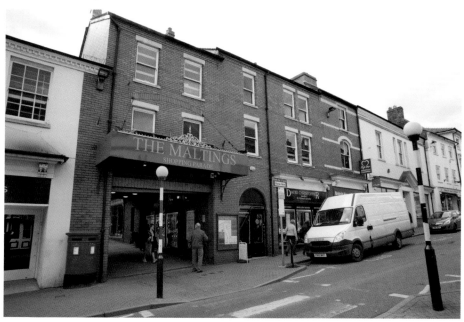

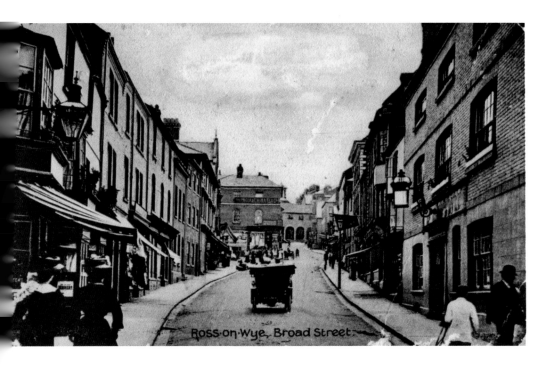

Broad Street

Looking up the street in the early twentieth century you can see that the main layout of the street has not changed at all. However, the roads are far busier with traffic and the shopfronts are modernised. You need to look up to see the original architecture of the buildings, with flats above – most of which remain today.

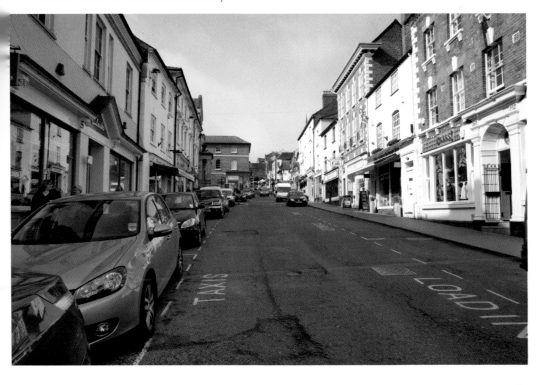

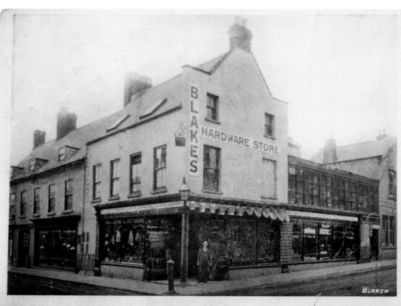

SANITARY
PLUMBERS.
HOT WATER
FITTERS.

Water Fitters to
the Local
Authorities.

Works: Blakes'
Ironworks and
Foundry, Broad St.,
ROSS.
Depôts: Blakes'
Hardware Stores,
Station St., ROSS.

BLAKE BROS., Manufacturing Ironmongers, Brass and Iron Founders, Hydraulic and Sanitary Engineers, Etc.

No. 35 Brookend Street, the General Tool Store

This 1907 postcard of Blake's hardware store, situated on the corner of Station Street, gives you an idea of the Aladdin's cave the shop must have been. It then became a family outfitter's before becoming a hardware store again around ten years ago.

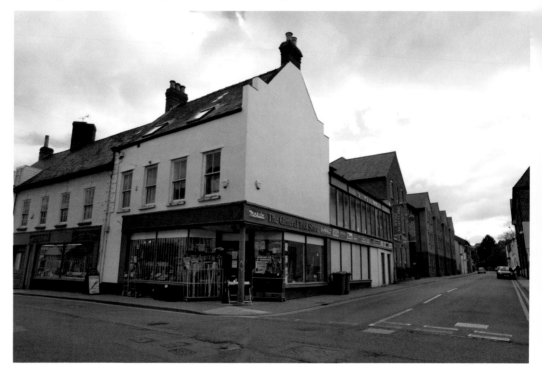

**Nos 30–32 Broad Street,
The Electric Shop**

Seen here in around 1930, Connie Dean is outside her Christmas window, a real eye-opener for the two little boys on the right. Connie and her brother John took over the running of the shop from their father, and it was a wonderful place to go to spend your pocket money on a Saturday morning. It was also the place to get your fishing tackle and licenses. Connie continued to run the shop until at least 1970, and was the grand age of ninety-five when she died.

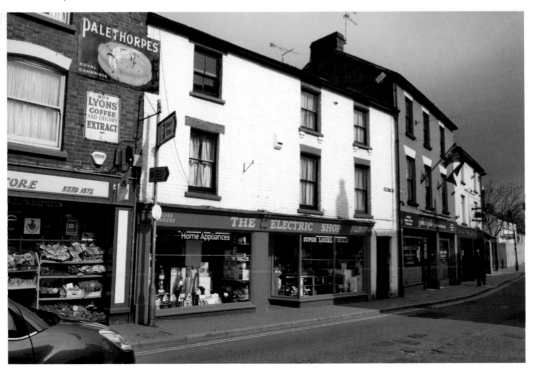

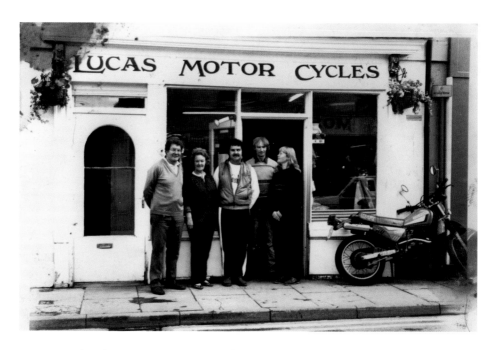

No. 34 Brookend Street, Lucas Motorcycles

In May 1952, the Lucases set up their motorcycle business. Over the years it became an institution in the town with customers from all over the world. Outgrowing these premises, they bought No. 34, which housed their shop and living space. Unfortunately, Gordon and Margaret died in 2012/13 within a few short weeks of each other. They were honoured by the biking community with a large turnout of vintage and modern bikes, which weaved their way through the town before their memorial services. The loss of yet more characters in Ross will be mourned, but this family business still continues, ably run by their children and grandchildren.

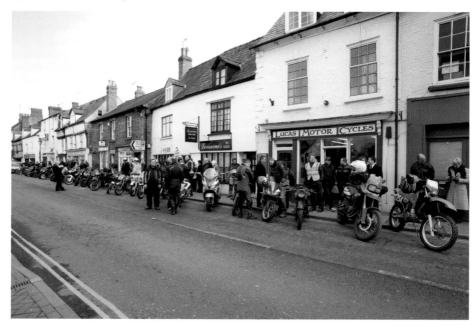

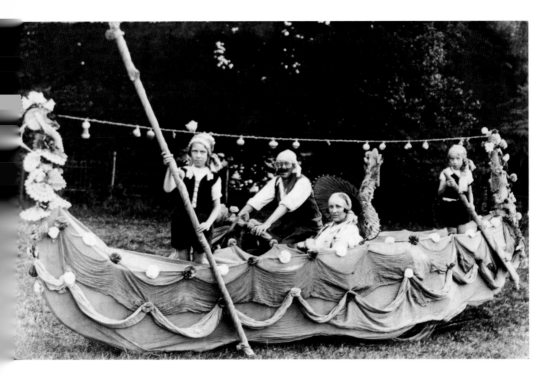

Carnival Day

This ingenious design from 1930 was built onto a motorbike and side car, and it could well have been the inspiration for then mayor and mayoress, Gordon and Margaret Lucas, when they led the procession in 2005.

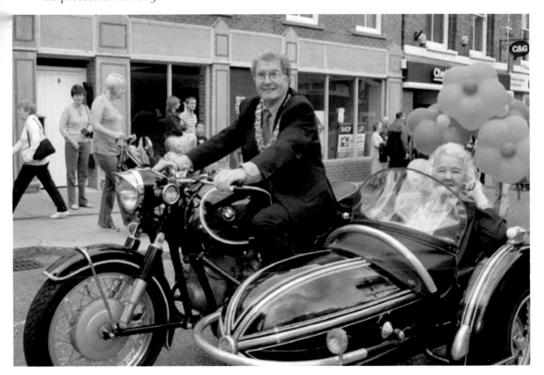

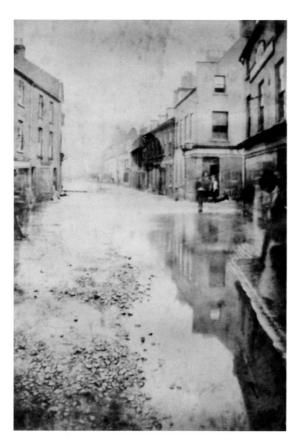

Bottom of Broad Street
As you can see from this early
twentieth-century picture, the street
often flooded well into Brookend Street.
Shops were regularly inundated with
water. This was a regular occurrence
following heavy rain until the early
twenty-first century, when a new
flood alleviation scheme was installed.
However, they still have some problems
if heavy rain pours down the street
from the Market House.

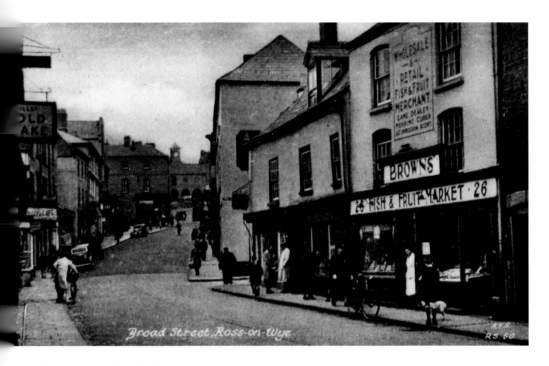

Broad Street, Gwalia Stores

Situated at the bottom of the street, this is now a very popular sight to be photographed. The bright metal signs were the advertising boards of their day. In the early days it was owned by Edward Powell, a very popular grocer. The Gwalia was across the road from where The Maltings was built, then moved into this shop. The original Gwalia was also a Temperance Hotel.

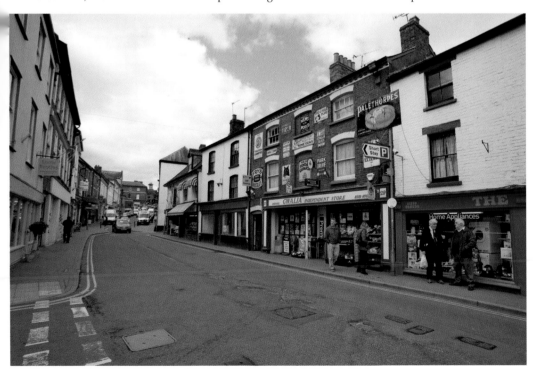

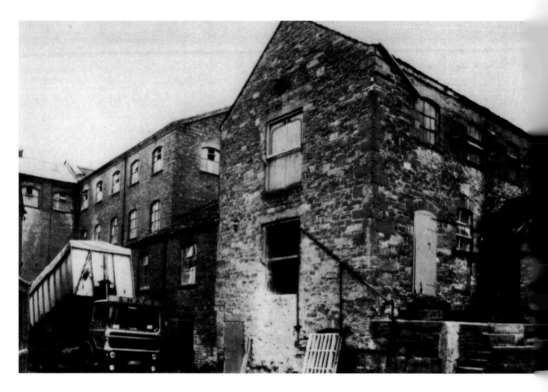

SHACS

South Herefordshire Agricultural Co-operative Society (SHACS) was formed in 1919. Here you see the town mill, which had been transferred to the firm shortly after it began. Wartime years saw a boom in profits, which continued until the 1970s when the firm became part of the Countrywide Group and moved to Ledbury.

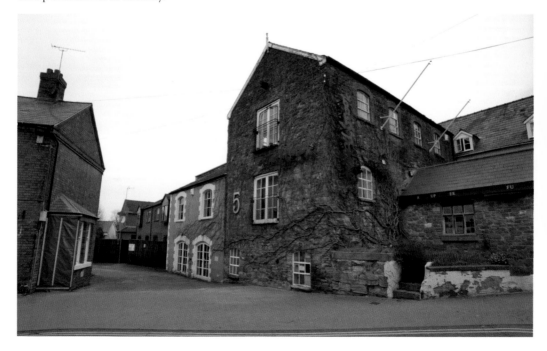

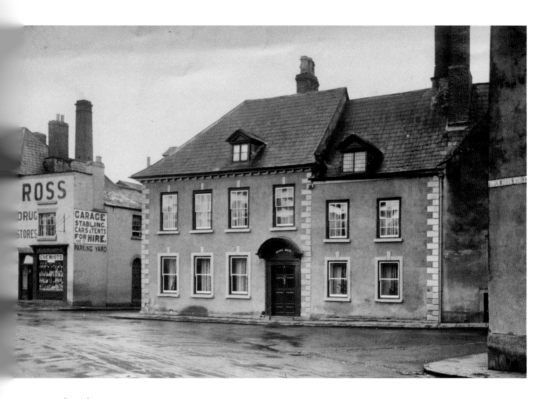

Brookend House

In the seventeenth century, Quaker John Merrick granted land and money to build a house, with part of it being used as accommodation for Quakers. This building still adjoins the original Friends Meeting House, which is used weekly for meetings and community events. Today the main building is comprised of flats owned or rented to local people.

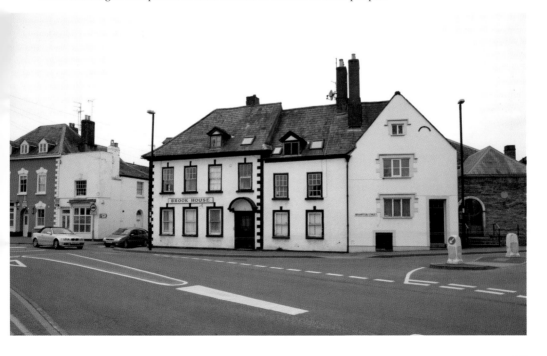

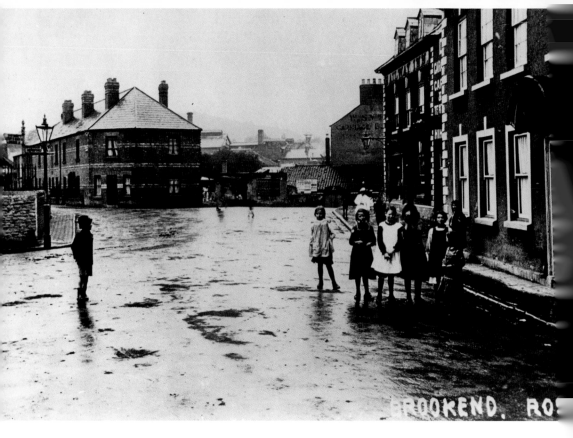

Ross Floods

This area, now Five Ways, was well known for flooding, not only because of the mill race that runs next to it but also due to the inadequate drainage of the time. Unfortunately, it also lies at the bottom of the hill, so water ran down from Brampton Street and Ledbury Road.

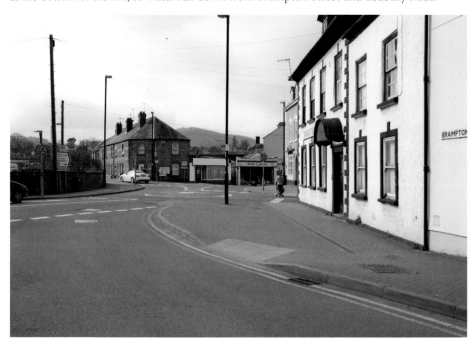

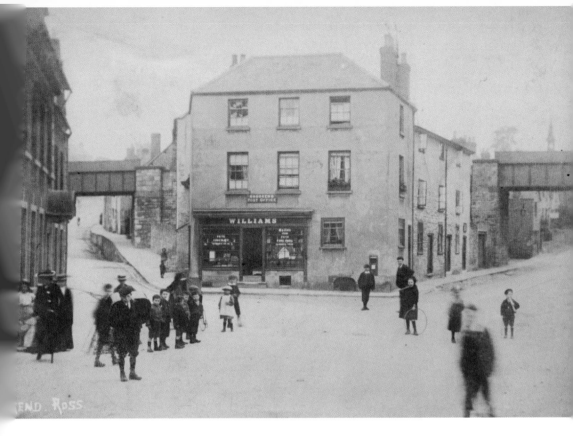

Five Ways

In this rare picture from 1912 the two railway bridges are still visible. By 1909 William Williams' well-stocked store had been installed with a post office. It also saw use as a boarding house run by his daughters. When the road was widened to create the now busy Five Ways junction, the site became a public convenience that was knocked down in the 1980s. There is now a display of Ross railway history here.

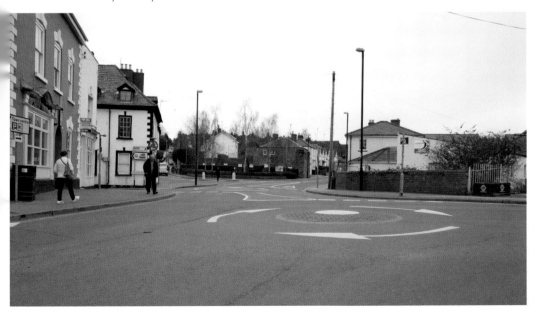

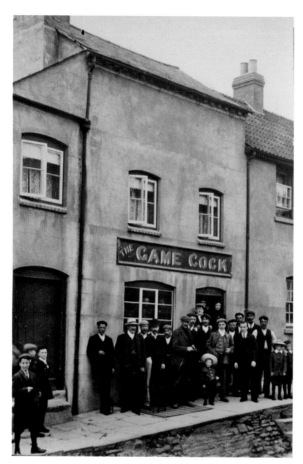

Game Cock

Established in 1851, this building was situated in Brampton Street, 30 yards up from the viaduct. This typical local pub had fifty workers' houses nearby for trade. They were demolished in the 1960s, leaving only three, and with all customers lost it closed. It was run by Alton Court Brewery, which ceased production in 1960. The site was sold and now forms part of a residential development.

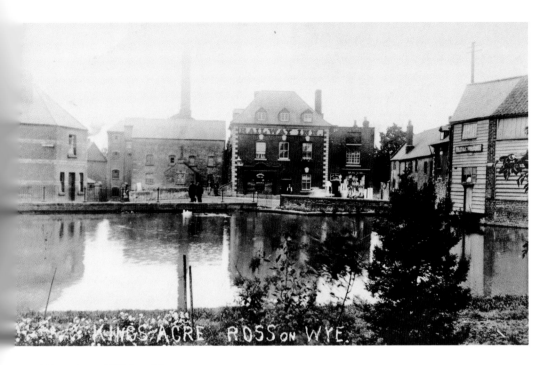

Kings Acre, Mill Pond Street

This area became known as Kings Acre in commemoration of King Edward VII's birthday. You can see the original gardens in this 1911 scene. The hub of the town was centered on this mill pool. It provided power for the waterwheel at the mill on the far side of Brookend. Water was replaced by steam in the 1890s. The pool became a refuse dump, which was filled in during the 1930s.

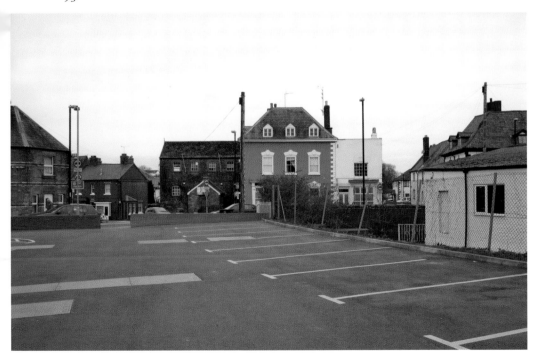

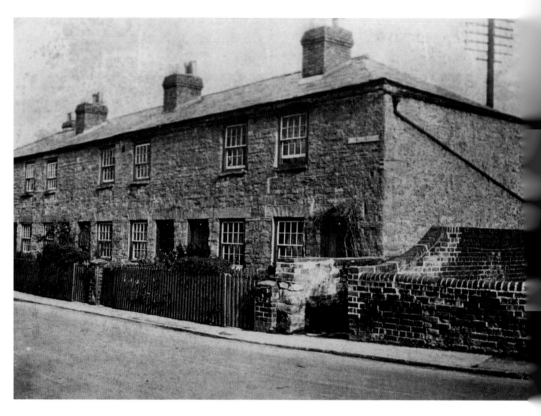

Wolverhampton Terrace, Millpond Street

The six houses shown here were removed as part of the slum clearances in 1935. Houses were demolished after becoming unfit to live in due to bad sanitation, damp and inadequate living conditions. They had to share one stand pipe, one drain and even one lavatory.

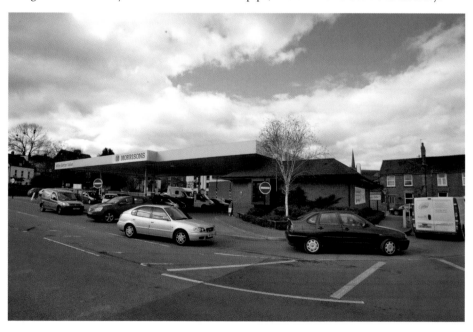

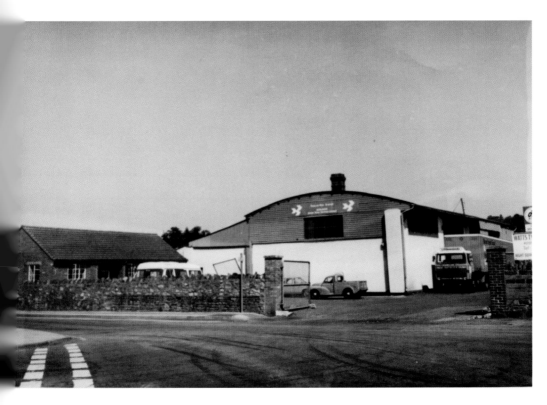

Morrisons (British Road Services)

After the slums were cleared the site became Kemp's timber yard and a British Road Services depot. When the railways closed in 1965 there was no longer a need for road services to deliver goods, so the site was developed by various companies selling a variety of goods including concrete, tires and carpets. Safeway took over part of the site as a supermarket and the whole area has been redeveloped into parking and a petrol station for Morrisons.

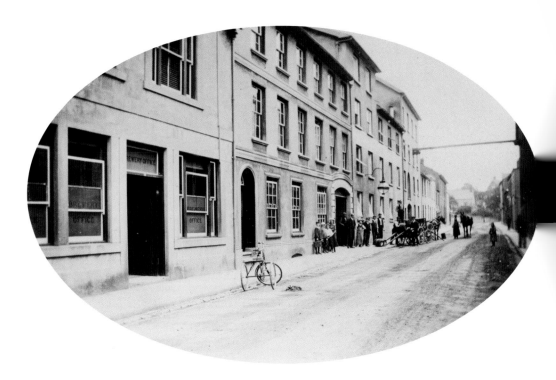

Station Street

Built in 1865, Alton Court Brewery dominated the street on both sides. The malt house to the right of this picture was where the main brewing took place, the left-hand side being the offices and areas for soft drinks manufacturing. Workers lived in the houses, and they had their own Taps Bar, where customers could come and fill their jugs with ales and other beverages.

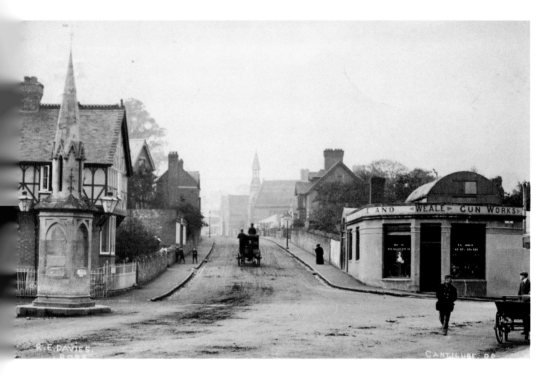

Cantilupe Road

You can just see the bell tower of the Council School through the mist in this 1900 scene. The memorial to nineteenth-century philanthropist Wallace Hall can be seen in its original position, before it was moved a few yards to make room for the roundabout and increased flow of traffic at the junction when the supermarket was built here. The omnibus has now been replaced by modern transport links.

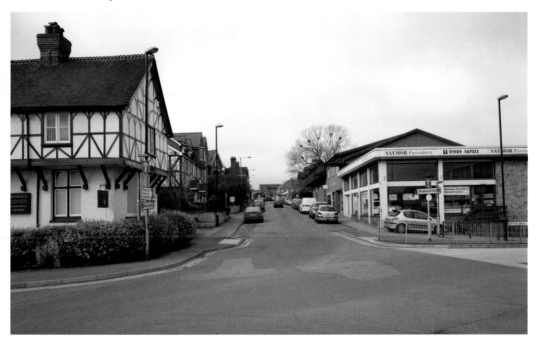

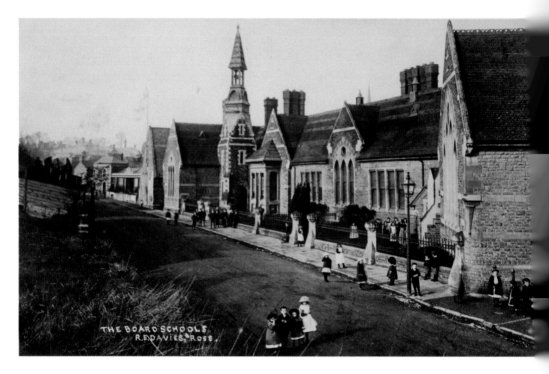

The Board School, Cantilupe Road

Also known as the Council School or affectionately by some 'Cantilupe College', the Board School occupied much of the street. It opened in 1874 with room for 426 children. The bell tower (*centre*) was demolished in 1943 and the rest followed in 1968 after being deemed structurally unsafe. Now the site of the library, all that remains are the gateposts and a few external playground walls.

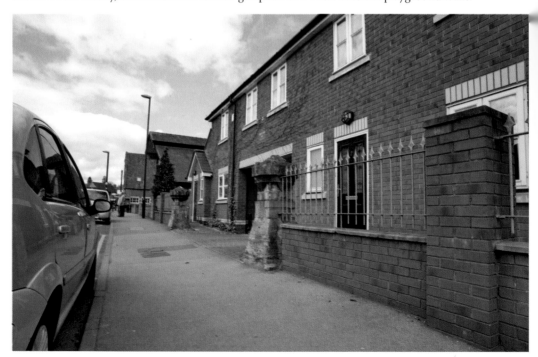

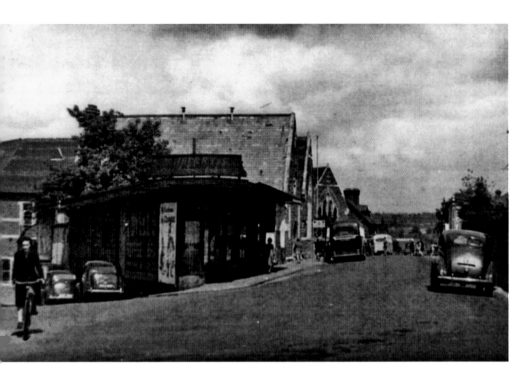

No. 1 Cantilupe Road, Crows Feet

This fascinating wedge-shaped building dates from pre-war days. On the site of a previous chicken run, it has seen life as a wool shop, a tuck shop and a grocer among other things. It was also the main waiting room for the buses, which have their depot here. It is now a shop selling a variety of gifts, accessories and other fancy goods.

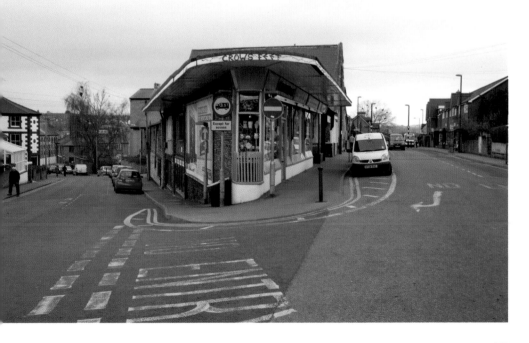

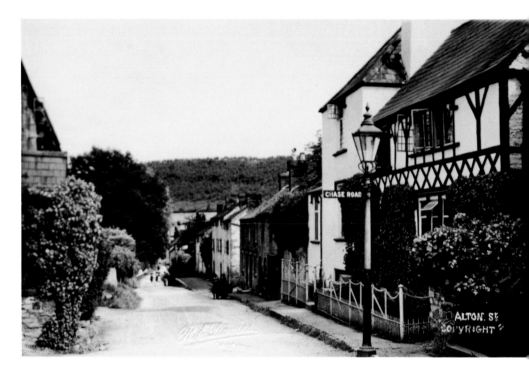

Alton Street

This was the main route from the east for those who wished to travel down the Wye Valley and into the Forest of Dean. This quiet backwater has been disturbed by the displacement of traffic from the one-way system, squeezing down this delightful street, which was more used to horse-drawn transport. The name derives from Old Town Street in local dialect.

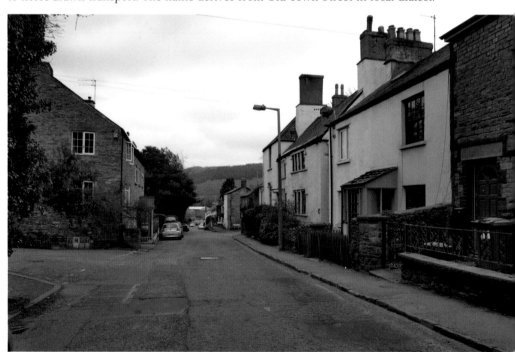

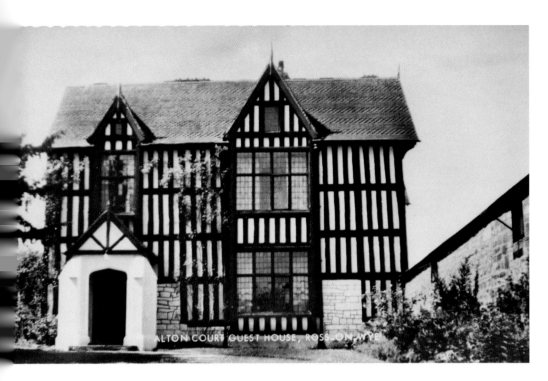

Alton Court

Nestling under Chase Hill, Alton Court was the estate where a clean water supply could be found, and this was piped into Ross, primarily to serve the brewery. At one time the town golf club was here, with the first tee and last hole being the opposite side of the railway line to the rest of the course. It is now the headquarters for PGL, an adventure activity company for children of all ages.

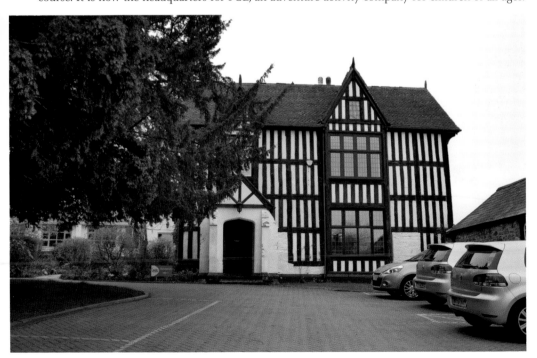

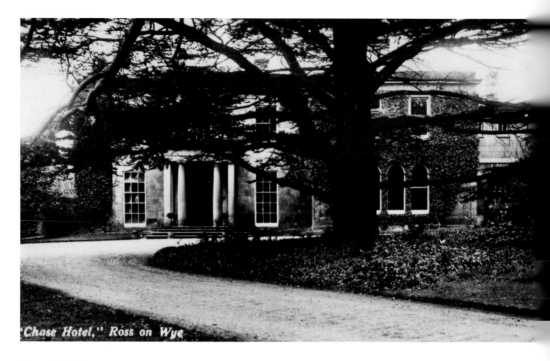

'Chase Hotel,' Ross on Wye

Chase Hotel

Named after the hill where the Bishops of Hereford hunted in medieval times, the Chase Hotel was built in 1818 but the mansion was not used as a hotel until 1927. Around 400 schoolgirls from Essex were evacuated there during the Second World War, only to find the one wartime bomb to drop on Ross narrowly missed them when it landed in the kitchen garden (but luckily did not go off). Following its use as a collecting box for the war effort, the bomb is now on display in the Market House Visitor Centre.

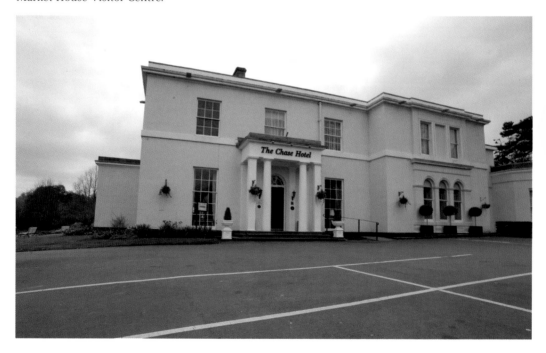

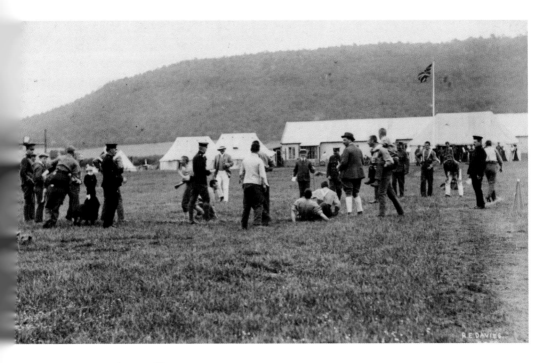

Army Camp, Chase Hill

The local regiments camped here during the late nineteenth and early twentieth centuries. It was an ideal place to practice manoeuvres for rifle training. During the Second World War, the Americans and Polish took it over, and it later became a prisoner-of-war camp for Germans and Italians. Many of the prisoners liked the area so much they married local girls and settled here. Today there is little left, but the rifle range is still used daily.

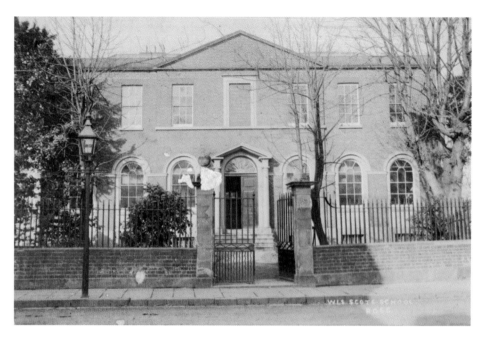

Walter Scott School

Born in 1716, the son of a local tradesman, Walter Scott attended the local charity school. At the age of thirteen he was caught scrumping pears, and rather than face the punishment he ran away to London and became an apprentice for his uncle, a master plasterer. After visiting Ross to find his school in a neglected state, he convinced locals to revive it and, on his return to London, changed his will to provide a permanent endowment for the school. He died a year later in 1786. His body was brought back to Ross and buried in the parish churchyard, where a white memorial stands prominently next to the path to the main door. In 1799 the school was officially established as Walter Scott's Charity School. As the school of his youth it was also a Blue Coat School.

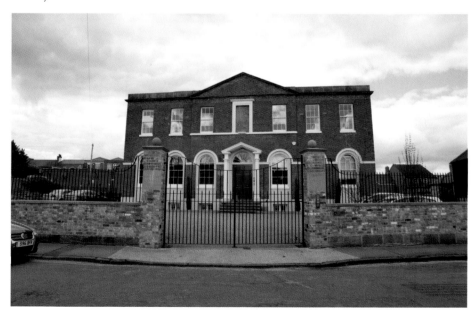

Cottage Hospital, Gloucester Road

Built in 1879 by public subscription, it had ten beds and a private ward. Fundraising added an operating theatre in 1897, with an x-ray room, children's ward and annex following in 1921. Patients who could afford treatment were charged and fundraising contributed to the treatment of those who could not. Townsfolk were very generous with donations of fruit and vegetables, magazines and money. Better-off families paid an annual subscription, published weekly in the *Ross Gazette*. It was demolished in 1997 when a new Community Hospital was built and the site has now become retirement flats.

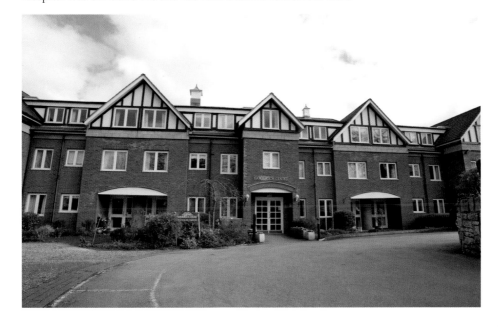

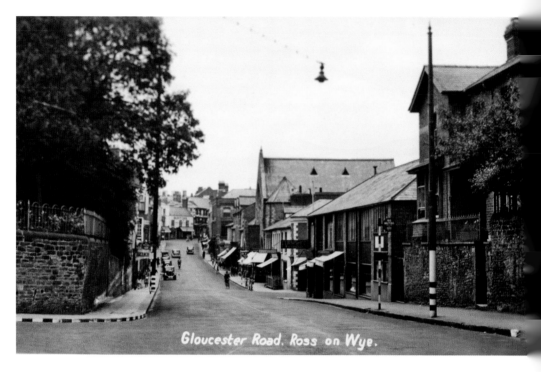

Gloucester Road, General View

Dating from the 1940s, the white bands on the posts were probably to help the large Army vehicles negotiate the narrow streets. Very little has changed in this scene, and apart from the trees on the left being cut down the buildings remain unaltered.

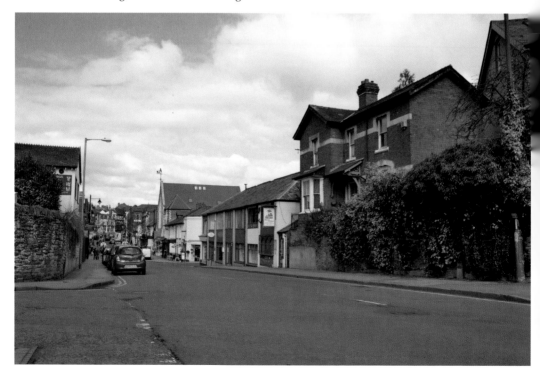

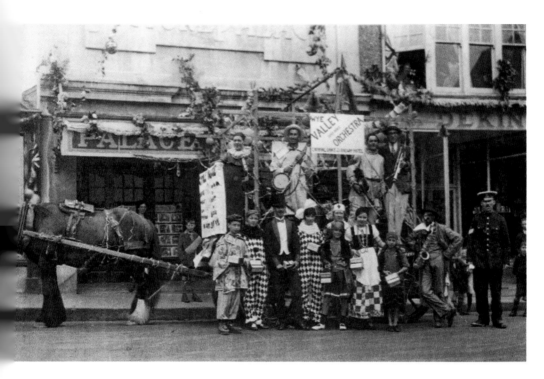

The Kyrle Picture Palace

Founded by the Dekin family, this was the place to go for all-round traditional entertainment. It was a theatre and cinema very popular with families. A whole day could be spent shopping, visiting the cinema, eating fish and chips and going home very tired on the back of the horse-drawn cart. Around 1913 there was much fun to be had in dressing up for the annual carnival. Unfortunately, it could not compete with the modern Roxy cinema and was demolished to make way for a supermarket.

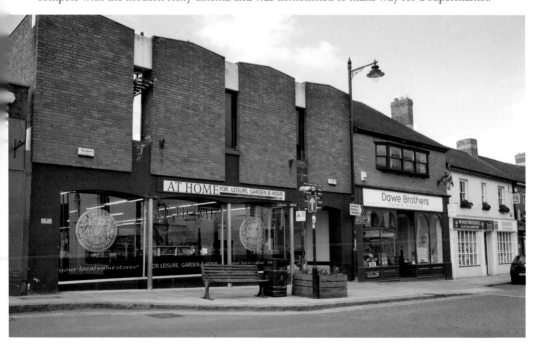

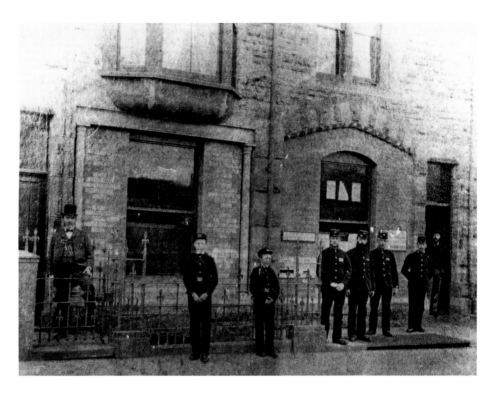

The Old Post Office

Purpose built as a post office and sorting office in the 1890s, this building was used for many years until the postal system was streamlined to come in line with modern-day transport. J. D. Weathspoon took over the building and turned it into a bar and restaurant called, appropriately, The Mail Rooms.

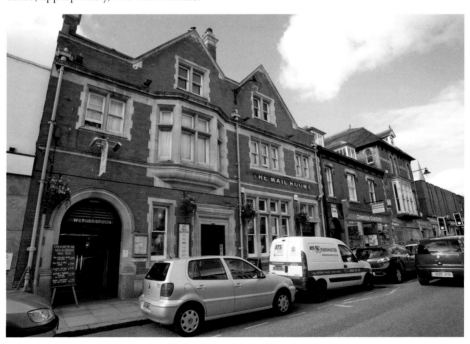

No. 12 Gloucester Road
Like all buildings in Ross many of the shops began as the front rooms of houses. For many years the shop on the right was a barber's, and one can possibly imagine this gentlemen on his way to somewhere after having just had his hair cut.

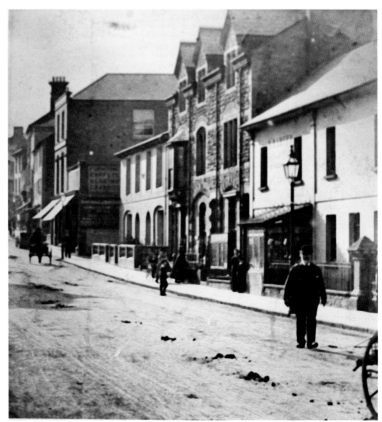

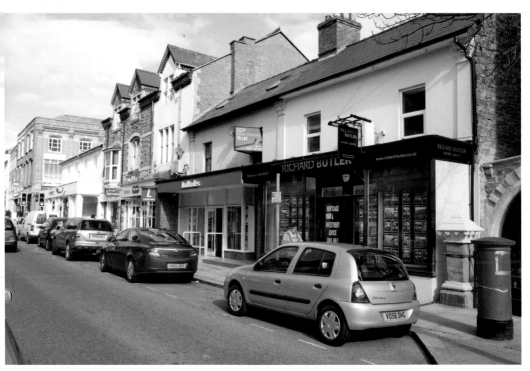

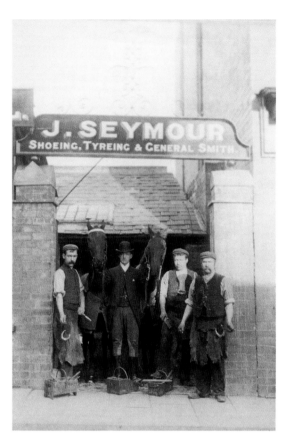

**No. 8 Gloucester Road,
Wye Dean Health Shop**
Seen here around 1900, Joseph Seymour
was a farrier's. It was demolished
and became one of numerous family
butchers. It was taken over by Colin
Smith as his Market Garden, selling
fresh local fruit and vegetables. Behind
it was the yard and ovens for the Central
Bakery in Broad Street, run by the
Williams family until a few years ago.

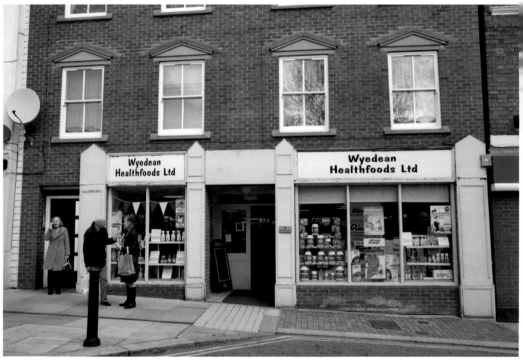

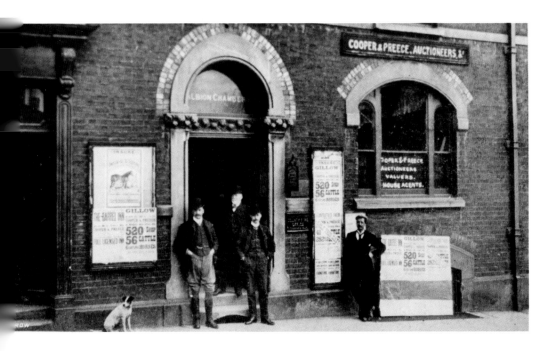

No. 3 Gloucester Road, GYTE Outdoor Leisure

Cooper & Preece were the local auctioneers, seen here during the county council elections of 1907. The occupiers of the shop may have changed over the years but the building remains the same today as it always was. For many years it was the home of South Herefordshire Agricultural Society (SHACS), corn and feed merchants. They had their own mill in Henry Street where the Sainsbury's car park is now.

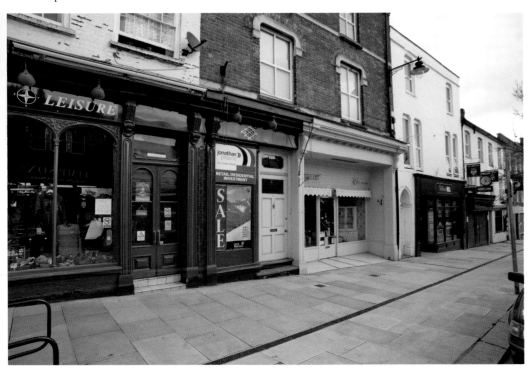

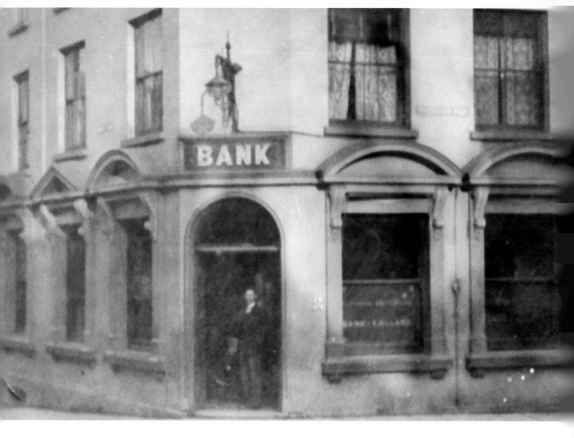

NatWest

Standing on the corner of Gloucester Road and Market Place, this is one of the longest-serving banks in Ross. The modern building is still recognisable today, despite a few structural changes. It was able to increase in size when it took over the building known as No. 1 Gloucester Road in the mid-twentieth century. The name of the bank may have altered slightly but it is still recognisable from this 1920 image.

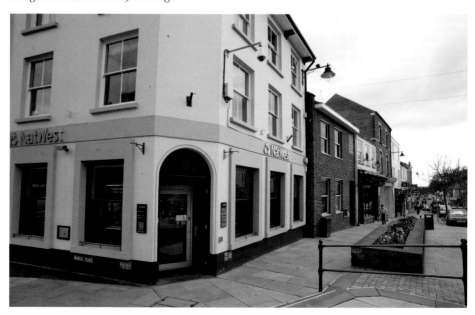

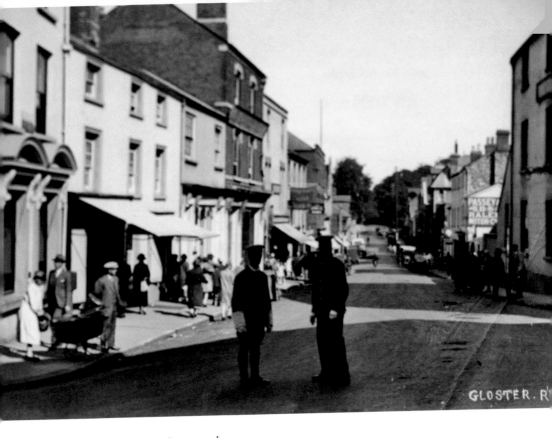

Gloucester Road, George Crossroads

A usual sight at the George Crossroads during the 1940s and '50s was a policeman on point duty. This was an important duty during wartime, when heavy vehicles were passing through the town, as this was part of the main A40 from London to Fishguard. The AA and RAC would help out at busy times, especially if the local bobby was patrolling the streets.

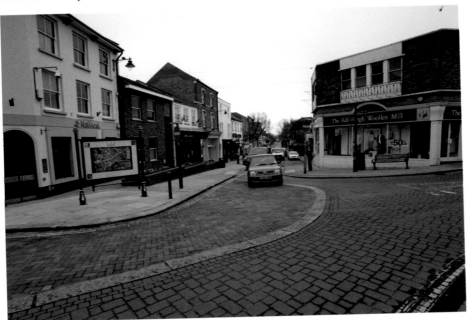

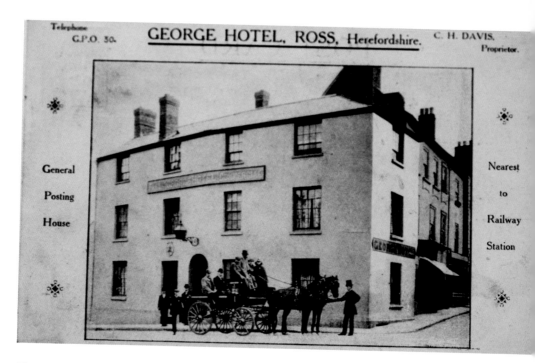

GEORGE HOTEL, ROSS, Herefordshire.

C. H. DAVIS,
Proprietor.

General

Posting

House

Nearest

to

Railway

Station

The George Hotel, Corner of High Street

The hotel's horse-drawn brake stands outside ready to take guests on a sightseeing tour *c.* 1910. The large, imposing building was very popular with farmers visiting on market days as they served a 'good ornery menu'. They were one of the first hotels to take advantage of the railway station, sending traps to meet visitors getting off the trains looking for accommodation. The building fell into disrepair and was demolished in the 1960s to make way for a row of shops, which now includes the Edinburgh Woolen Mill. Arthur Conan Doyle loved visiting Ross, and it is believed he based Holmes' stay in Ross at the George Hotel in the *Boscombe Valley Mystery*.

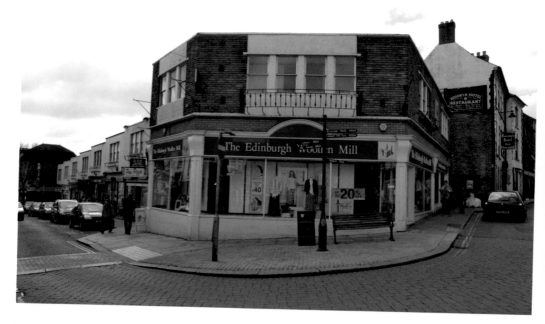

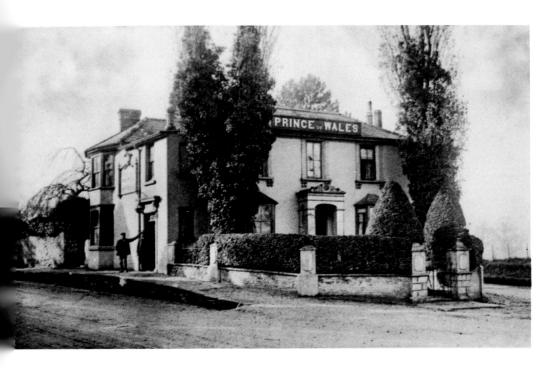

The Prince of Wales

Situated on the Walford Road and Archenfield junction, the Prince of Wales has altered very little since the late 1800s when it was established. In this 1905 picture you can see a building typical of its period. It offered 'Good Accommodation for Tourists, Cyclists and others' and boasted a 'very healthy situation' in this leafy suburb of the town.

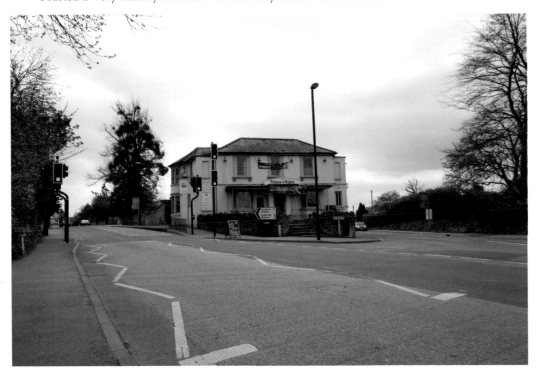

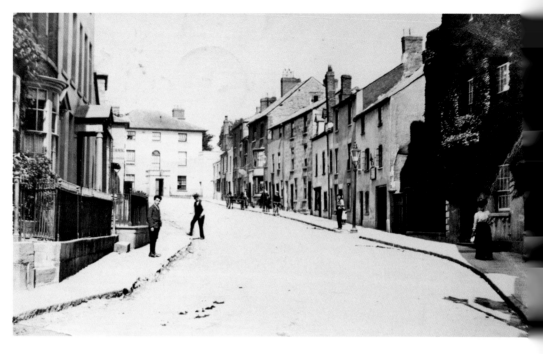

New Street

Still overlooked by the Merton Hotel, New Street retains the character seen in this 1907 picture. Many of the cottages on the right were demolished as part of the Slum Clearance Act in the 1930s. At one time this street was full of farriers, blacksmiths and nail-makers serving the surrounding coaching inns with new horseshoes and repairing wheels.

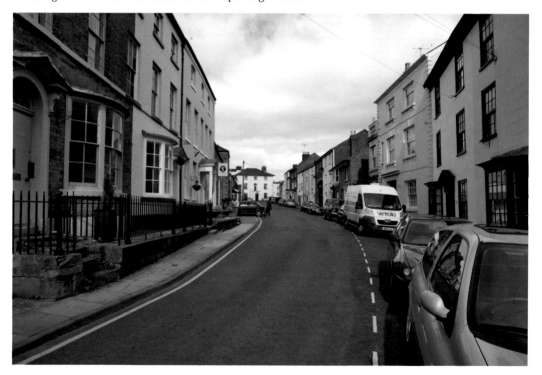

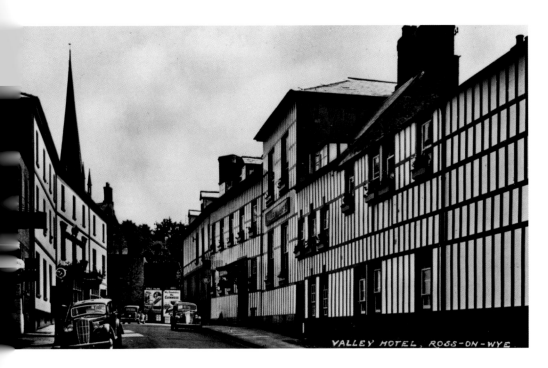

Valley Hotel, Edde Cross Street

Despite competition from grander coaching inns, the hotel was in business for many years. The black-and-white frontage, not genuine Tudor, disappeared when it was converted into flats and offices. During the Second World War, the Japanese embassy evacuated their wives and children here. It was a safe haven from the bombing in London and within a few hours' travel by train, enabling workers to spend quiet weekends away. As soon as war was declared on Japan they moved out.

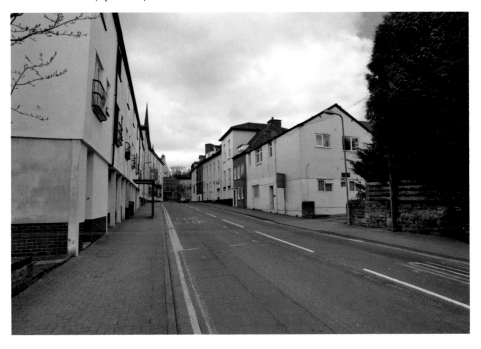

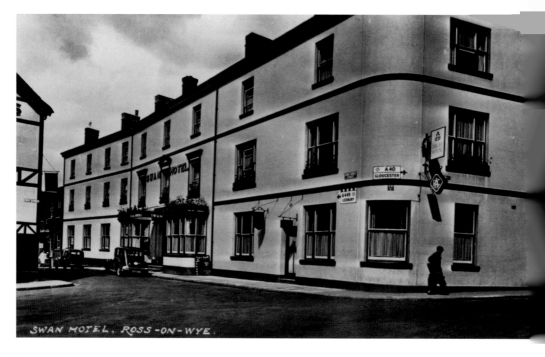

SWAN HOTEL, ROSS-ON-WYE.

Swan Hotel

This was built especially to accommodate the growing number of tourists and cater for the farmers and buyers who packed the streets on market day. In its heyday it was a prominent coaching inn and continued well into the mid-twentieth century as a place to hire coaches and taxis. Recently it has been used as council offices and will soon be given new life as luxury flats.

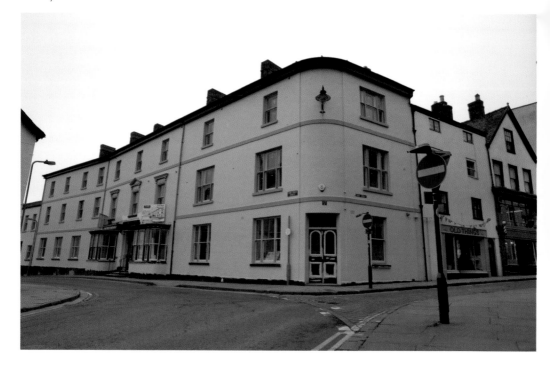

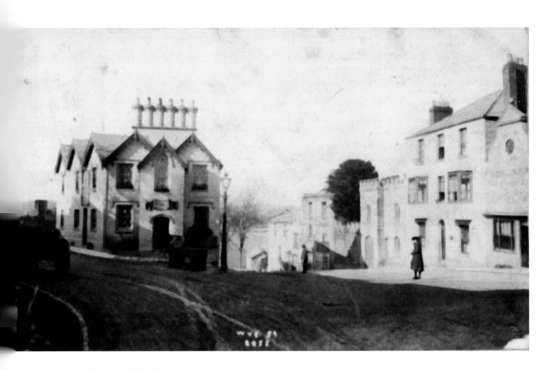

Malvern House, Wye Street

When the new Wilton Road was built, houses were knocked down to push the road through. The building to the left became the Castle Hotel, probably reflecting the castellated walls that sprang up to match up with the mock town walls and towers. During the war it was very popular with troops, being the only place non-officers passing through could get a drink.

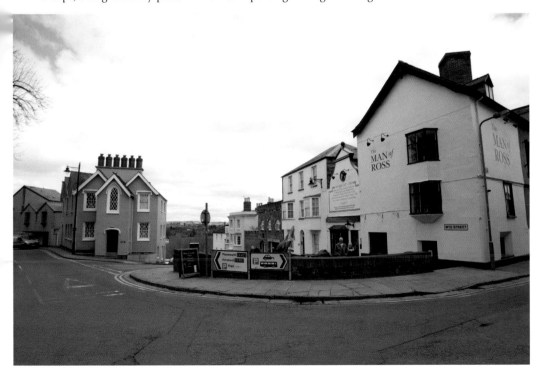

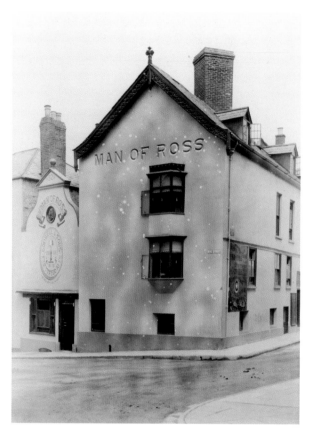

Man of Ross Inn

Housed in a building dating from the seventeenth century, the Man of Ross Inn opened in 1847. Serving continuously as an inn since then it has recently undergone refurbishment and the sign has been repainted by specialist sign writers. It was very popular with tourists on their way to the riverside to catch pleasure boats. Walenty Pytel's sculpture depicting Wye salmon was placed outside here in 1997.

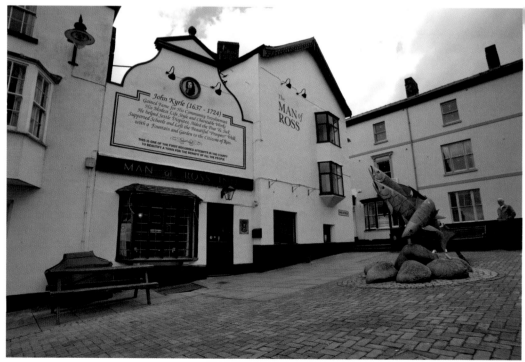

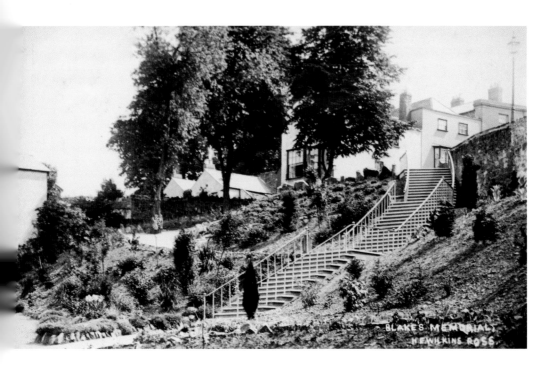

Blake's Memorial Garden

The site of the original bathhouse, the garden seen here in 1908 was constructed to commemorate the work of benefactor Thomas Blake. His most notable achievements include providing a clean water supply, extending the mains supply to serve the railway station, purchasing No. 20 Broad Street as a Free Library and paying towards the modernisation of the Baptist chapel. In recent years this area has enjoyed a revival from local volunteers for Ross in Bloom and the Diamond Jubilee celebrations.

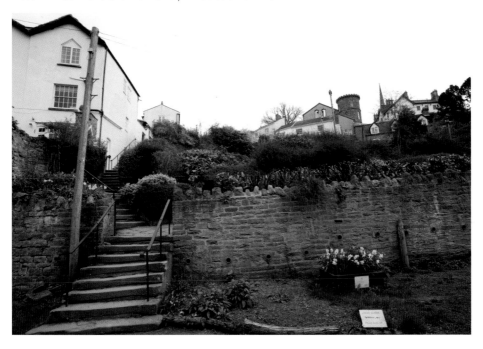

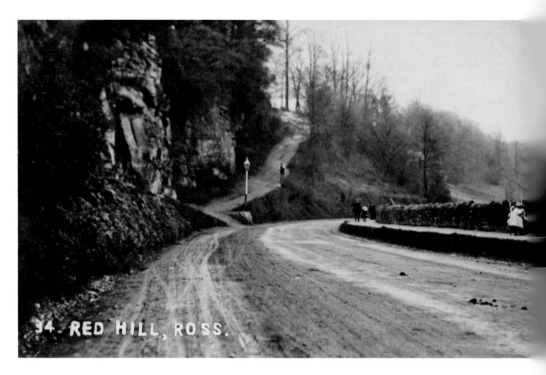

Approach to Ross, Wilton Road

Horses have left their mark on Wilton Road as it curves towards the river. Red Hill was used as a walkway through to the south side of the town via the escarpment. It was given its name locally when the new road was being cut into the red sandstone, causing the hill to become red with the dust.

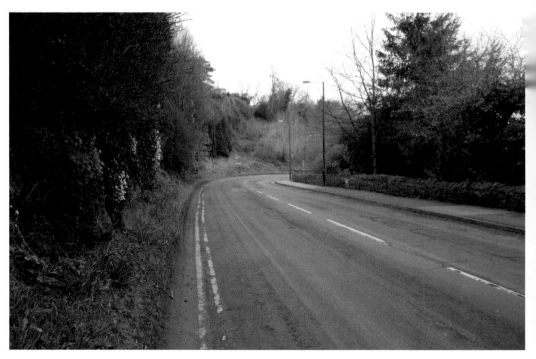

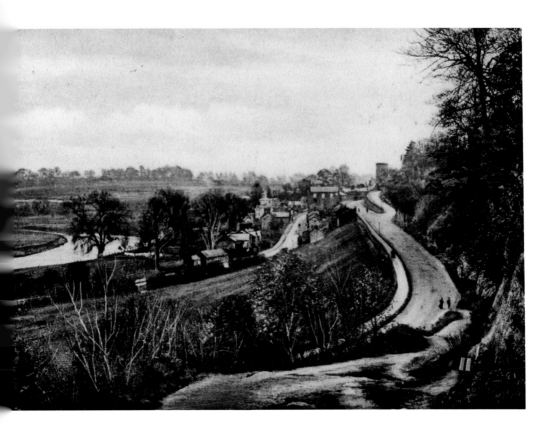

Approach to Ross from Red Hill

In the 1905 postcard above very little has changed from the current view. Although the Wye is now behind the trees it is still a lovely place for a scenic view. The sandstone escarpment can be walked along and forms part of the John Kyrle Walk.

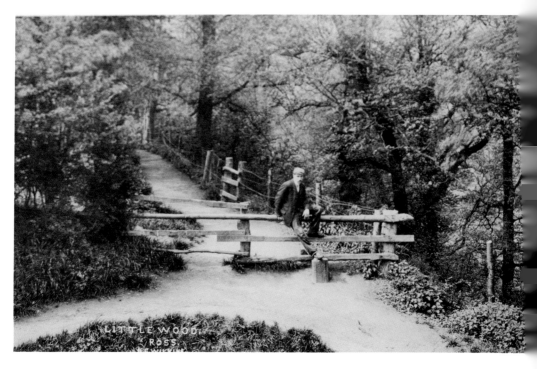

The Lover's Seat, John Kyrle's Walk

A stile found on the walk that winds its way around the sights of the town and its surrounding countryside. There are many stories on the origins of its name: one describes the plight of two lovers who, forbidden by their fathers to see one another, would meet here at midnight and share the only time they had together gazing up at the stars.

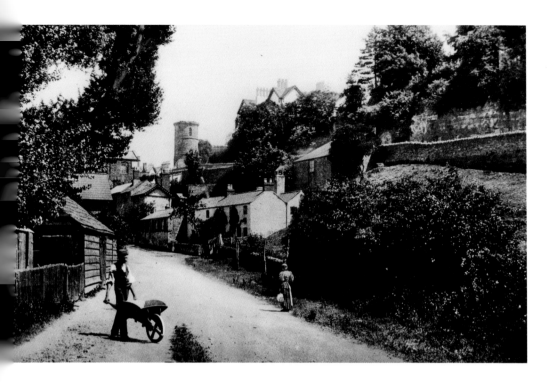

Wye Street

Originally called Dock Pitch, this street ran alongside the river and regularly flooded as it still does today. Although some of the street has been built up with houses, the lower part is a superb place for recreation around the Millennium bandstand.

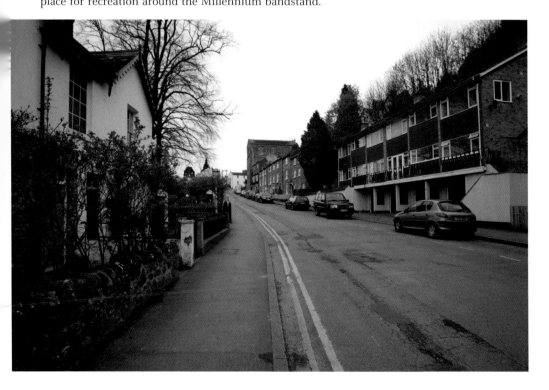

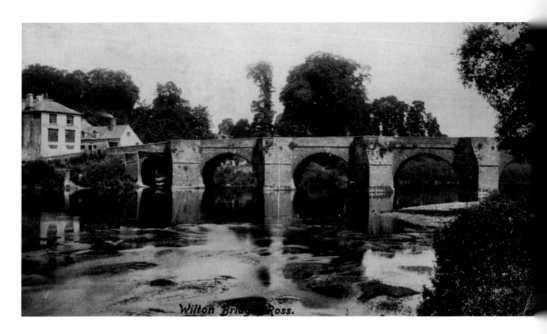

Wilton Bridge

Before its construction the only way to cross was by ford or ferry. Thirty people drowned at one point when the ferry overturned, which caused the bridge to be built in 1599. It has been the main access road into Ross ever since. During the Civil War one arch at the far end was blown up for defensive purposes and the parapets on the north side were removed to widen it for military traffic during the Second World War. In 1637 Wilton villagers left food in the parapets to feed townspeople during the plague, which isolated the town for many months. The old ferry landing stage is now marked by a commemorative cross.

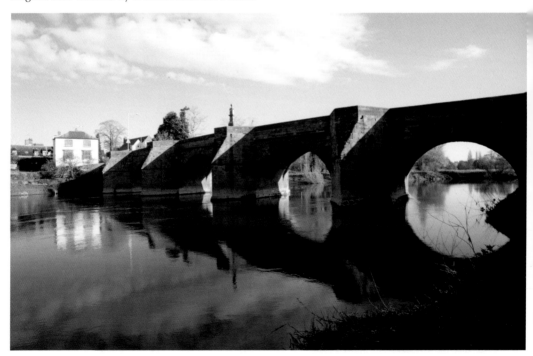

Sundial on Wilton Bridge
Erected in 1712 by Jonathan Barrow of
Bridstow, the inscription reads:

> Esteem thy precious time
> Which pass so swift away,
> Prepare then for eternity
> And do not make delay.

There are many theories as to why it was
placed here. Whatever the reason, it's a
lovely landmark.

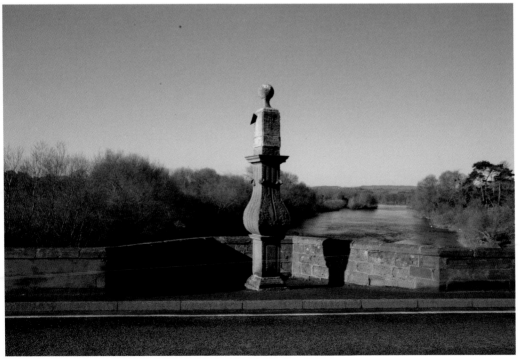

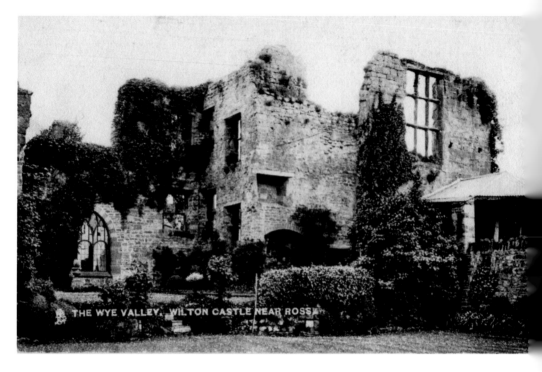

THE WYE VALLEY. WILTON CASTLE NEAR ROSS

Wilton Castle

Built in 1141, the castle's unusual position close to the river meant that it was built to defend the ford crossing point and later the bridge. Royalists, provoked by the owner's neutrality during the Civil War, decided to burn it to the ground one Sunday morning when the family was at church. Over the last ten years it has been extensively restored and is now open to the public on certain days of the year. It also serves as a popular wedding venue.

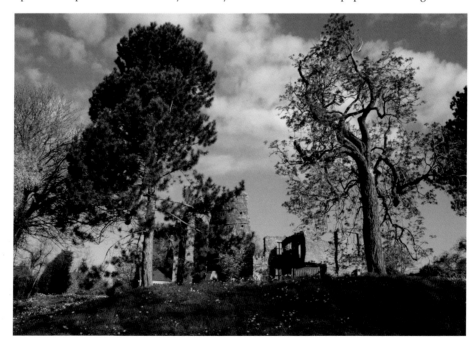

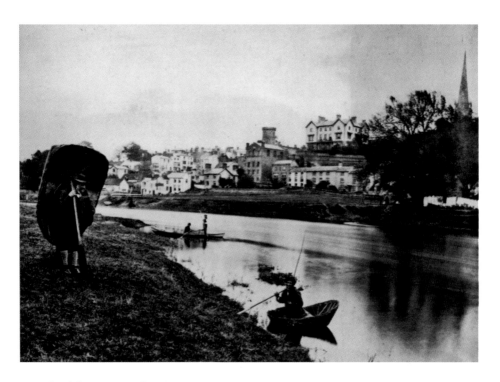

Coracle Fisherman on the Wye

Taken around 1870, the fisherman on the bank is believed to be Sammy Jones, who died in 1883 at the grand old age of ninety-three. He was a familiar sight on the river and a master of the coracle, a vessel difficult to manoeuvre but silent in the water – ideal for both fishermen and poachers. The name comes from the Latin word *corium*, which means animal hide. The waterproofed leather was stretched over a wooden frame. It could be found in use all along the River Wye for transporting both people, goods and for fishing on the stretch of water below the Hope and Anchor.

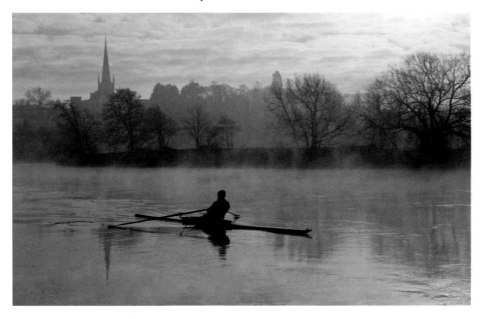

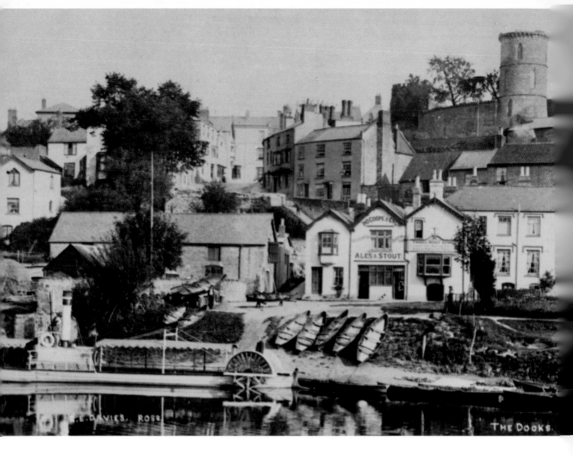

Wilton Castle Steamer
Owned by Henry Dowell and built in his boat yards in front of the Hope and Anchor Inn.
Trips went down the Wye to Chepstow. As part of the Wye tour, modeled on the Grand Tour
made popular by the Victorians, it must have been a great way to take in the scenery of the
spectacular Wye Valley. Now the river is too silted up for such vessels, and only canoeists
and rowers are lucky enough to take in the scenery from the river.

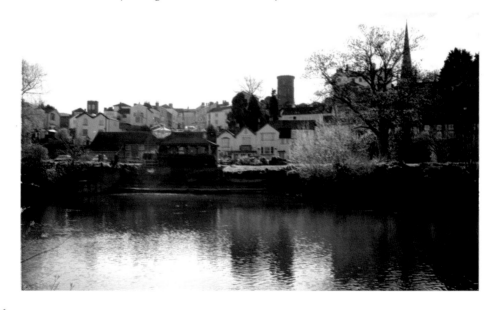

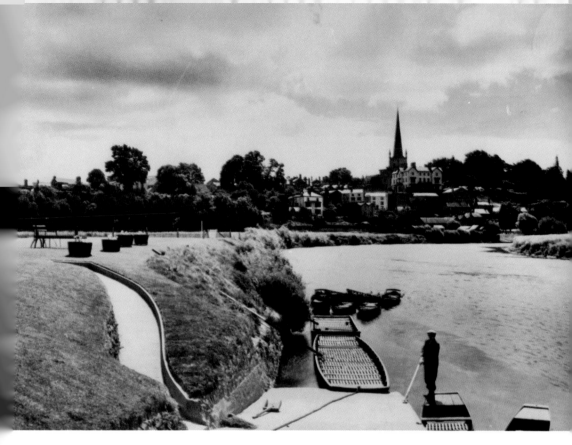

Rowing Club

Established for over 100 years, the club is one of the main centres in the county for regattas. It will be one of the main sites in 2014 for the River Wye Festival. It was a popular place for fisherman to cast from and punts docked for pleasure trips like the one in this 1930s picture.

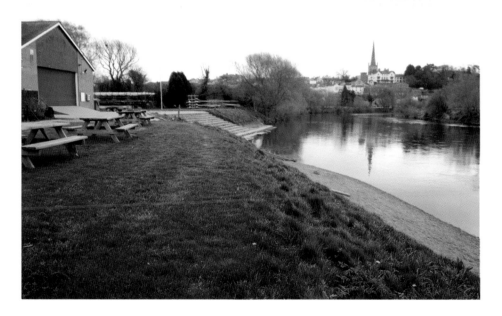

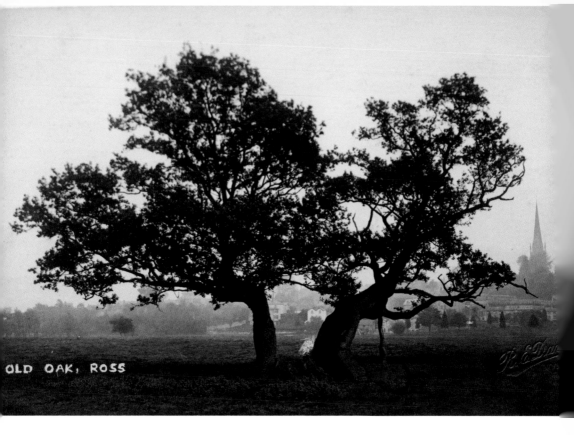

OLD OAK, ROSS

Old Oak

Thought worthy of its own postcard at the start of the last century, and also known as the Doomsday Oak, the Old Oak is still standing to this day. When it was struck by lightning over fifty years ago, a new tree was planted to ensure there would always be an oak tree there when it eventually died. Both trees are still growing healthily side by side.

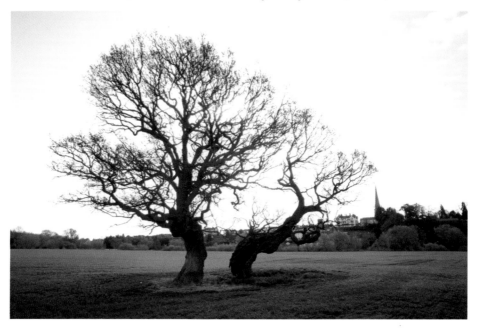

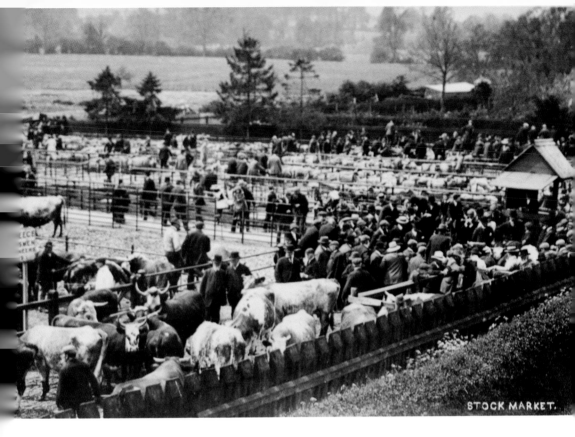

STOCK MARKET.

Cattle Market at Homs Road

Opened in September 1871, the market replaced the long-standing venues in the town streets. Its movement benefitted the town, as the streets were cleaner and there was less noise and disruption. Being nearer to the railway transport links meant the animals could be dispatched quicker. The market stood here for over 100 years before it was moved to Over Ross in the late 1980s and the site was used for housing and car parking.

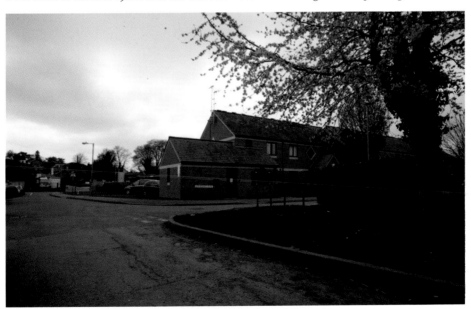

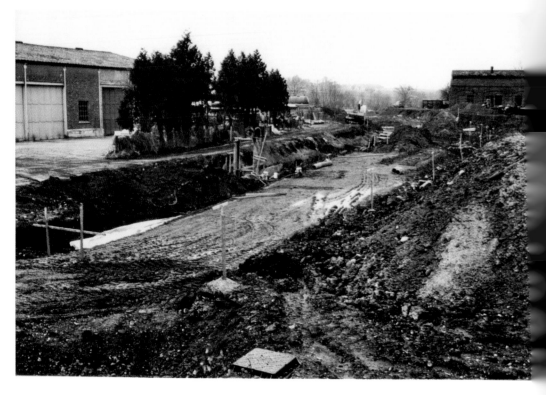

Ashburton Estate

This has been built on the site of the railway station and goods yards. The station building and goods sheds were here, and goods could be collected on lorries to deliver around the local area. There were also large coal yards where customers could either collect their coal or order it to be delivered. Passenger services ceased in 1964, and goods stopped the following year when the line closed completely.

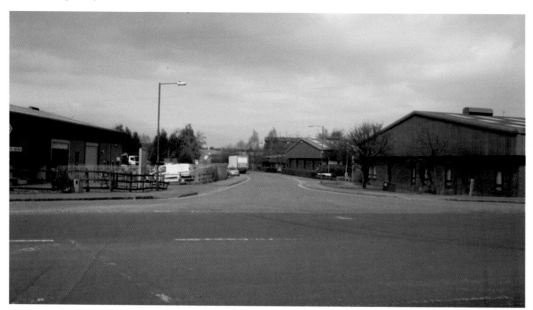

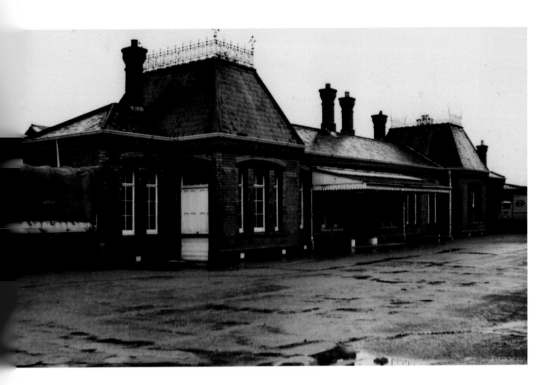

The Old Station

The Hereford, Ross & Monmouth Railway, 36½ miles in length, received Royal Assent in 1845. This fine station was built in 1891, thirty-six years after the opening of the Hereford & Gloucester line. A victim of Beeching's cuts, it closed in 1964 and was demolished in the 1970s. An exact replica of the station can be found on the Severn Valley Railway station at Kidderminster. The Wye Valley line between Ross and Monmouth previously closed in 1959.

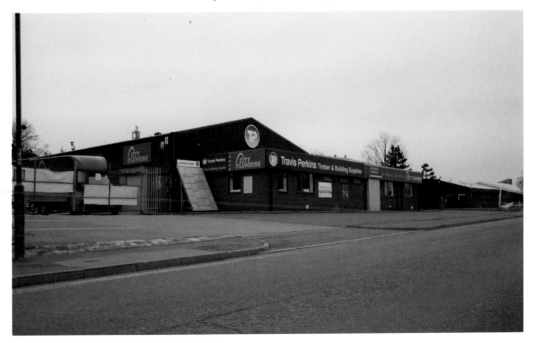

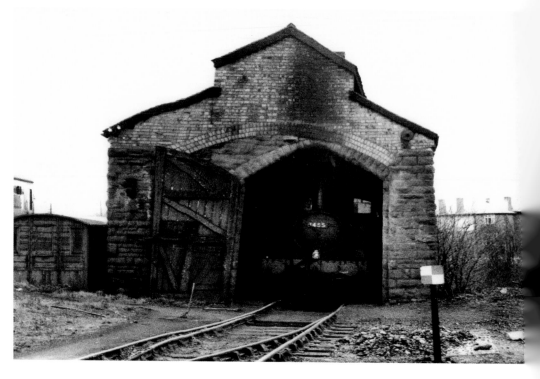

Engine Shed, Ross Garden Store

Designed by Brunel, this imposing building can still be clearly seen from the A40. You can still see the two arches at the end of the building. It was altered to accommodate the larger goods engines, which were higher and had larger tanks for more pulling power. Today it is a popular garden centre.

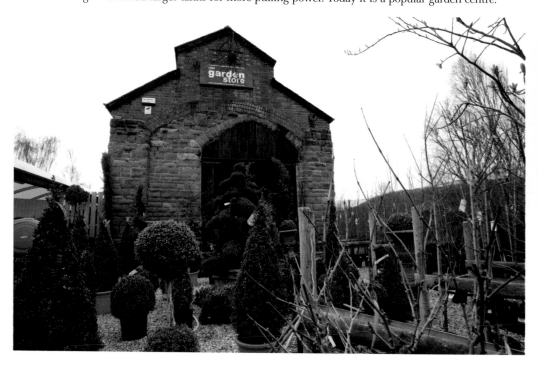

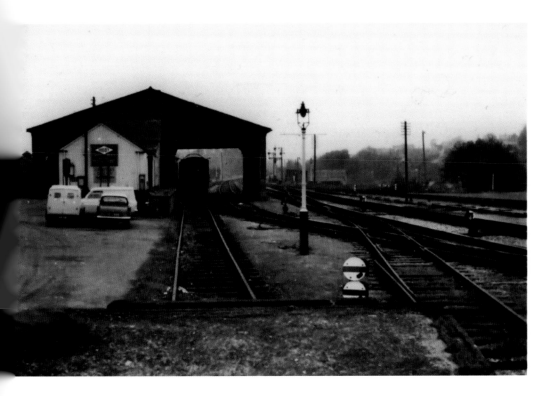

Goods Shed, Fleetcare Services
Goods like coal and timber came up from the Wye Valley as it was the main station between Hereford and Gloucester. It's a shame small lines like this were closed and we now have to rely on road transport.

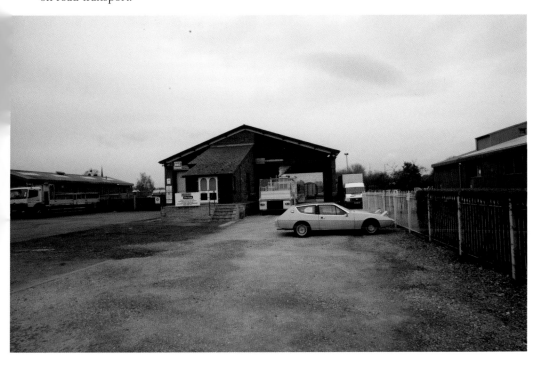

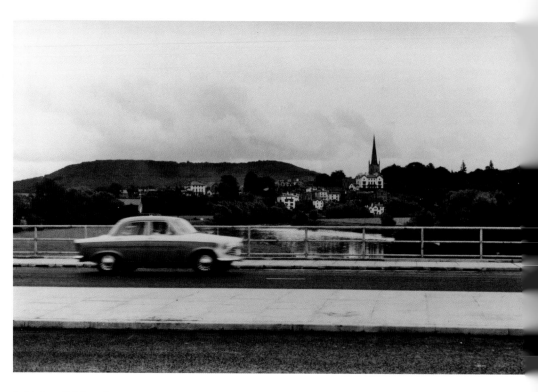

Bridstow Bridge, A40

As part of the major rebuild of the A40 South Wales/M50 Midlands road improvements the bridge was built to span the river. Traffic no longer had to travel through the centre of Ross, particularly after the north bypass was built.

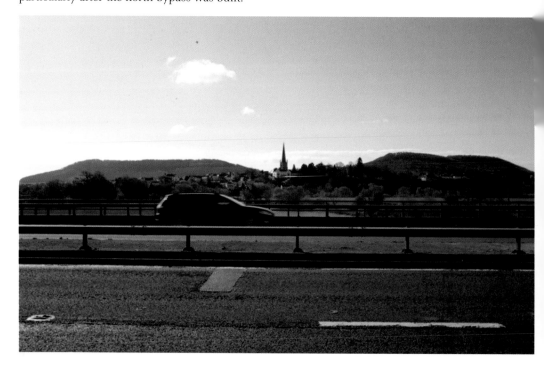

Ledbury Through Time

Michael Lever

This fascinating selection of photographs traces some of the many
ways in which Ledbury has changed and developed over the last
century.

978 1 4456 1525 7

96 pages, full colour